CREATING COMIC CHARACTERS

Other Books by Dick Gautier

The Art of Caricature
The Creative Cartoonist
Drawing and Cartooning 1,001 Faces
Drawing and Cartooning 1,001 Figures in Action
The Career Cartoonist
Drawing and Cartooning 1,001 Caricatures

CREATING COMIC CHARACTERS

DICK GAUTIER

A Perigee Book

A Perigee Book
Published by The Berkley Publishing Group
A member of Penguin Putnam Inc.
200 Madison Avenue
New York, NY 10016

First edition: December 1997

Published simultaneously in Canada.

The Putnam Berkley World Wide Web site address is http://www.berkley.com

Library of Congress Cataloging-in-Publication Data
Gautier, Dick.
 Creating comic characters/Dick Gautier—1st ed.
 p. cm.
 ISBN 0-399-52351-0
 1. Cartooning—Technique. I. Title.
NC1320.G375 1997
741.5—dc21 97-9777
 CIP

Printed in the United States of America

10 9 8 7 6 5 4 3 2

Contents

To Jean

Before We Begin

This book was inspired by and is the direct result of many conversations with artists of all ages who have tried their hands at cartooning and drawing (some as a result of digging into and wading through some of my previous books). Their problems, the obstacles they could not seem to surmount, and the questions they posed all seemed to funnel down to one basic thing—the difficulty they encountered in creating characters when they sat down at their drawing boards.

They were suffering from the "sameness syndrome," the graphic equivalent of writer's block. They were quite comfortable drawing the same limited set of figures and faces but, for some inexplicable reason, they couldn't cut loose, branch out, boldly go where other cartoonists fear to go. Their hands seemed to automatically return to those same configurations, as if some deep-seated muscle memory was taking control of their unwilling hands. Unfortunately, many of them got bored or frustrated and gave up—at least temporarily.

I don't believe that anyone has to be stifled or intimidated by that part of the creative process. There are many ways around everything. There are tricks that we can play on ourselves and with ourselves to ignite our temporarily dormant creative imaginations. The human face and form are metaphorically a blank canvas and we, as artists, have the license (and the not-so-solemn duty) to put whatever we want wherever we

want. That is our God-given right—to distort, to warp, to exaggerate, to minimize, to play with the usual allotment of ears, hair, and chins and do whatever we wish with them (within the bounds of general recognizability). And what a wonderful opportunity it is; what a delicious sense of freedom! So let's take advantage of it and have some fun in the process. I think that is the operative word—fun. I recently went through two years of piano lessons to find myself temporarily abandoning my musical dream, and while reflecting on the experience I discovered why—I wasn't having any fun. Scales and exercises go only so far, and after that you want to be able to make actual music, to play a simple ditty or two. So with that resounding defeat still ringing through the halls of my memory, I will strive to make this book a learning experience, yes, but most of all—fun.

B reak Those Blocks

One of the pitfalls of the creative artist is and has always been sameness, redundancy—getting just a little too comfortable with one attack, one approach, and then merely coming up with variations of that same thing over and over again. *Q'uelle ennui!* This, of course, eventually has a numbing and suffocating effect on artists so that, egos notwithstanding, they can actually get bored with their own creations. Now, I'm not saying you shouldn't develop your own style, but I am addressing that particular hang-up that prevents you from experimenting as an artist in order to let your own style emerge. It's only through experimentation and trial and error (lots and lots of error) that we allow our style to emerge. And emerge it will.

I've always maintained that style is any artist's most valuable asset (more so than talent) because it is totally individual—it's *your* style, no one else's. That's why I stress drawing as much as you possibly can, because invariably, insidiously, without your really being aware of it, your style will somehow mysteriously emerge. I don't believe that artists consciously choose a style; they merely go about doing their work while that incredibly complex network of memory, influence, taste, and muscle combines to form their style. It's one of the great mysteries of art. Who knows why Modigliani painted the same strange, almond-eyed, narrow faces repeatedly? It made him famous (though not while he was alive), so I'm not decrying finding a style and sticking with it. No, I'm addressing that creative rut that some of us are prone to fall into from time to time.

We're going to be focusing primarily on the head because, after all, that is where our features, hence most of our character, resides. But just because we're concentrating on this area doesn't mean that you should neglect working on the body and its infinite capacity for expressiveness (as illustrated in my previous book *Drawing and Cartooning 1,001 Figures in Action*).

Have you ever noticed that sometimes when you sit down to draw, the same basic configurations appear? It's that old devil muscle memory taking over; that memory that has gained strength from your hand sketching those same lines over and over again. You're in a creative rut—"creative rut" being one of the better oxymorons. Now how do we claw our way out of it?

By way of brief digression, I'm an avid (I didn't say good) tennis player, and I studied with a teacher who mixed a little philosophy and psychology with the usual banal instructions. After a while I became aware of something tricky he was doing. He would take standard teachers' clichés, such as "keep your eye on the ball," and he'd paraphrase them to trick me. He'd cloak these well-worn phrases in other language and actually fool me in a sense to help me better realize my goal. For instance, he told me to "observe the patterns that the seams of the ball form as it comes spinning toward you." I became fascinated with the way the seams twisted and revolved. I hit the ball dead center and, surprisingly, hit it better. Of course I was merely "keeping my eye on the ball," but I was having a lot more fun in the process. That's exactly what I want you to do: have fun in the process of learning while expanding your ability to create.

I recently reexamined my own blocks and hang-ups to see what I could do about them. I forced myself to engage in some exercises designed to blast me out into creative space whenever monotony reared its unattractive head. It is as a result of those exercises and the students and artists I talked with about creating characters that this book was conceived. I believe that if you jump in and have fun with these exercises as I have, there is no reason to be stymied when you come up against that creative brick wall again.

The whole premise of exercise is to get the body to do something it doesn't do on a regular basis, and thereby work those basically unused muscles. Why do we do situps? Because obviously it's a movement we don't engage in very often in everyday life. Walking, yes. Stretching, yes. But situps? Hardly ever. So most of our mid-sections go soft.

I want you to engage in a series of exercises that might be unfamiliar to you so we can help combat any artistic lethargy that might have set in. Remember—the premise of restimulating your creative powers is based upon not what we usually do but what we *don't* do as a rule. So from this moment forward, whatever you usually did when you sat down to draw, *don't do it*. Let's shatter those comfortable patterns of behavior and see if we can't release a host of fascinating and original characters

that live inside you just waiting to be brought to life. Play along with me and you'll see how these visual antics will help to broaden your artistic horizons.

Much like going on a diet or quitting smoking, initially you have to break an ingrained habitual behavior pattern. For an example, instead of sitting down in the same place to draw, choose another. Do you usually draw with a portable easel balanced on your lap? Then switch to the dining room table. Or vice versa. In other words, shake up your paradigm, rearrange your stimuli. In some cases it's as simple as (if you usually start with the head) starting with the nose, or if you always start with the nose, starting with the head. Choose any feature that you never start with and then build upon it.

Cartooning, with the wide breadth of its accepted distortions, is so potentially versatile that I feel its rich depths have not yet been tapped. Obviously I don't know the kind of characters that you create so you're going to have to play along with me and adapt my suggestions to your own particular problems. So here is a series of playful exercises that I hope will help you destroy that stilted approach to drawing and release those powerful creative juices.

When you sit down at the drawing board, do you draw the same old loopy oval to begin with? Fine. Draw it.

And fill it in as you usually do.

Now let's turn that paper around 90 degrees and see what you have. A horizontal oval. Even that is a change, small though it may be.

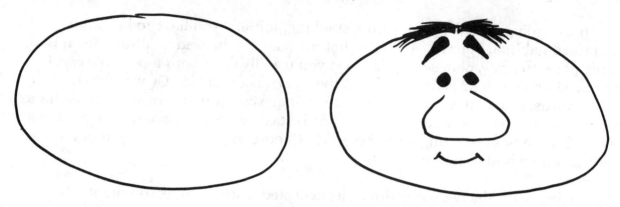

But did you see what happened? In the horizontal oblong I was forced to distribute the features differently, i.e., the tiny tuft of hair and the wider, bigger nose. Much like the goldfish who adjusts his rate of growth to the size of his pool, artists make adjustments depending upon the parameters they assign themselves.

Sometimes, after designing a character, I like to stretch it out in another direction, almost as if it were anamorphically altered. Again, this is designed to shake you out of your artistic doldrums.

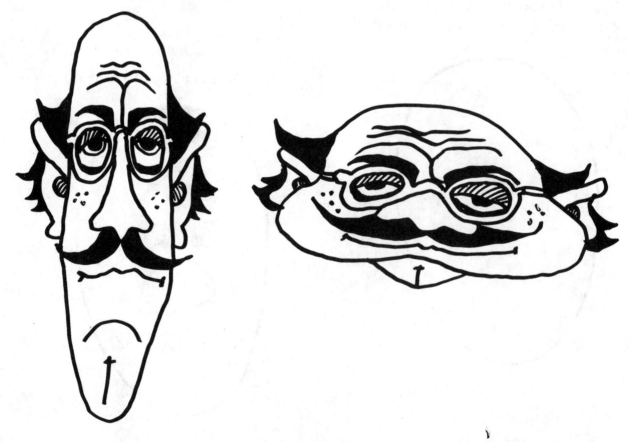

Before we discard that oval, let's play with it a little more—try cutting it in half.

Now let's fill in each of those halves as though each were a separate entity.

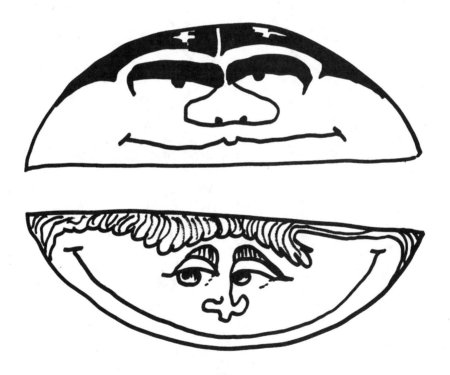

Weird, huh? But fun—and decidedly different. That's the important thing—does it alter your pattern at all? Does it make you look differently at things? Good.

Here's another idea—take that oval and add a second one perpendicular to the first. Now we have a rather peculiar shape—but one that can act as a springboard to some fresh ideas.

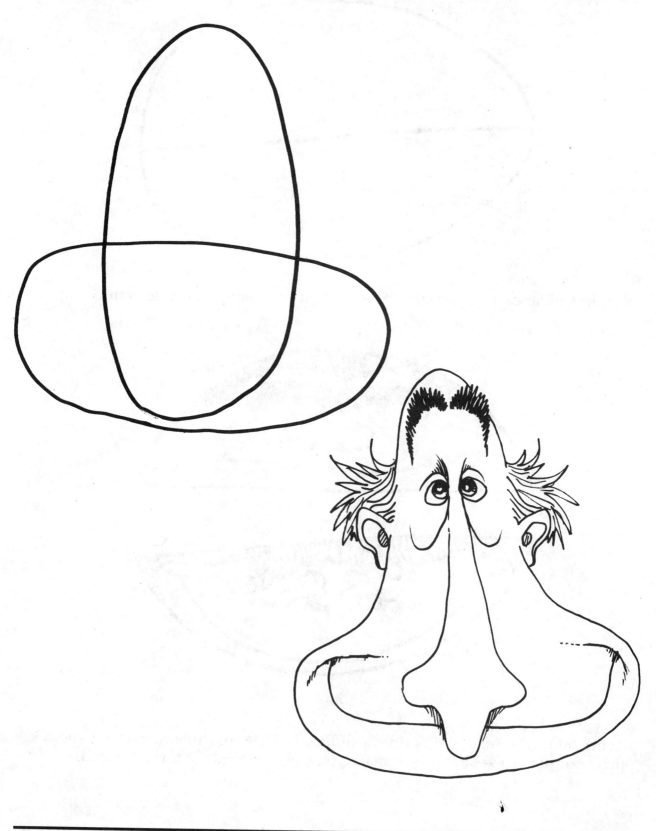

Now let's turn that upside down; as you can see, we come up with yet another configuration.

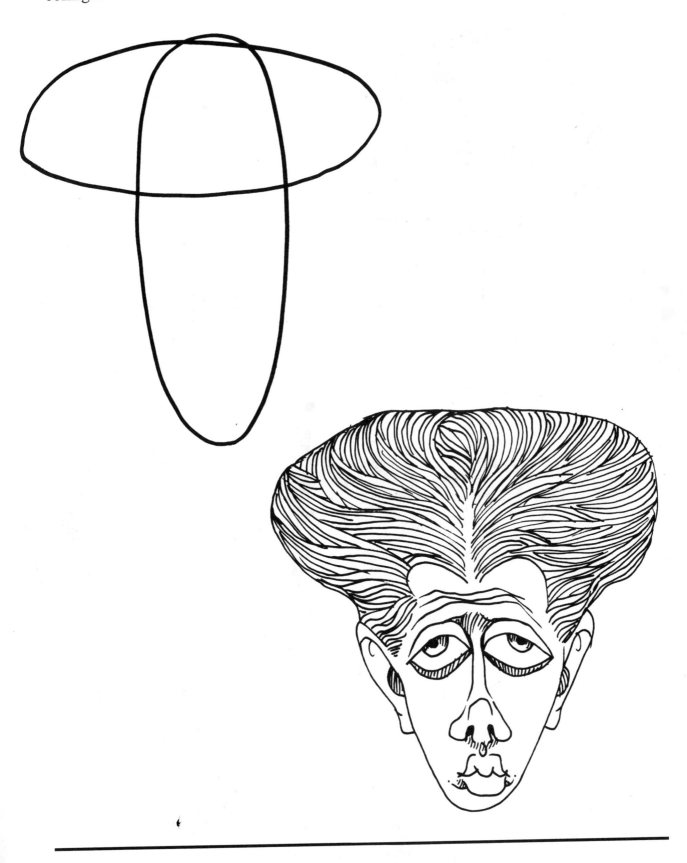

Another thing to try is the redistribution of features in different areas. Are you given to placing the eyes very close to the bridge of the nose?

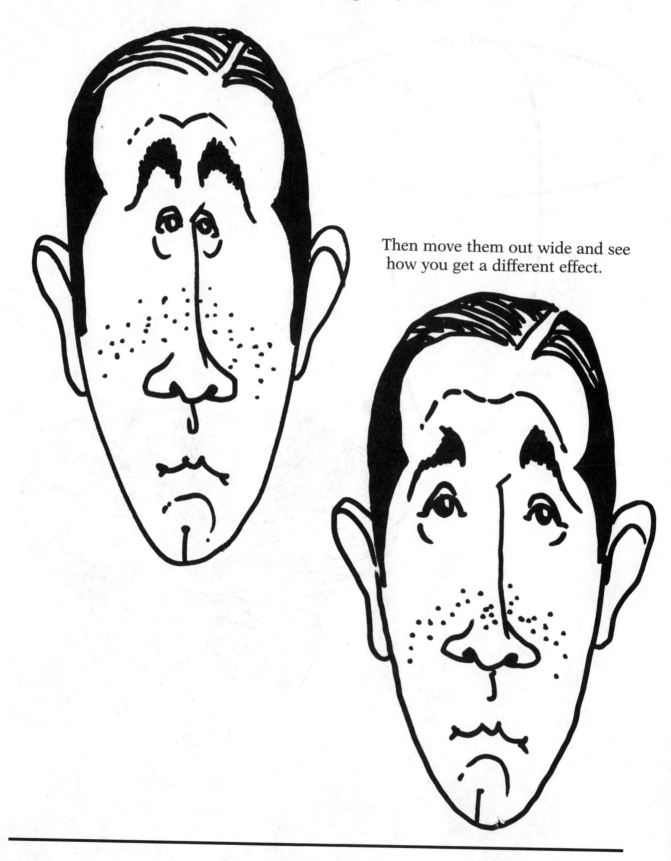

Then move them out wide and see how you get a different effect.

Here's something I like to play around with—draw an oval and give it a couple of dots for the eyes.

And fill in the remainder of the features.

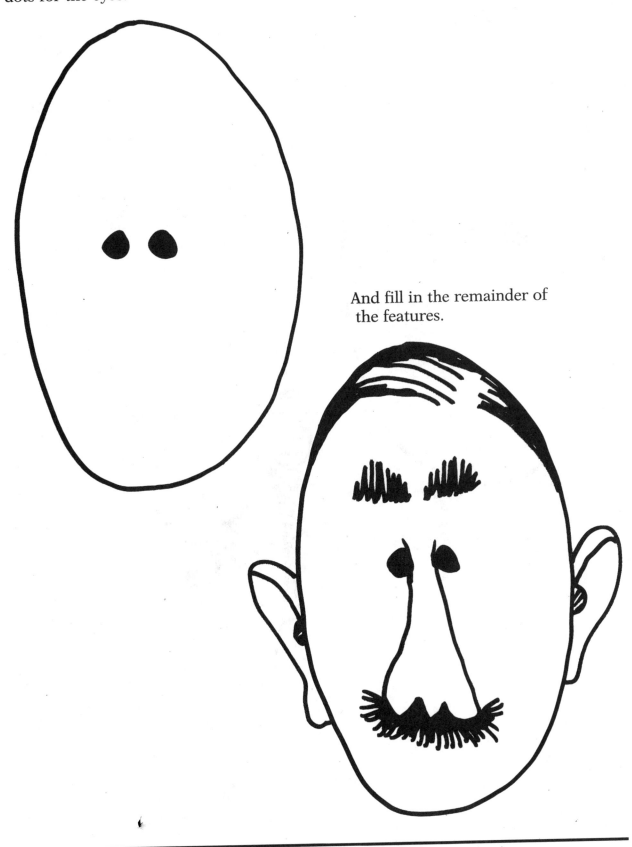

But now, go back to the oval and the
two dots.

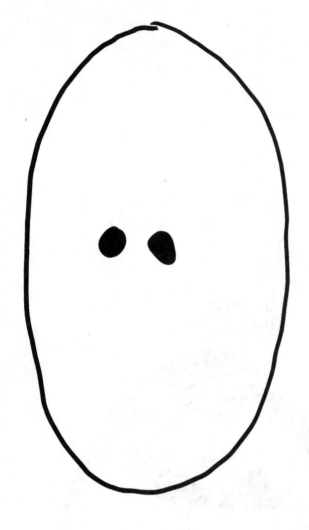

Squint at it—what if those dots
were nostrils?

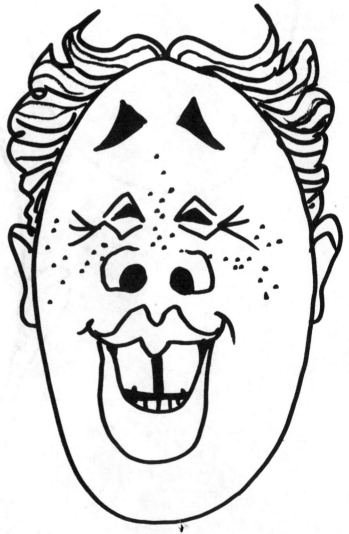

See? You've just rearranged your thinking pattern, or at least perceived those areas in a different manner, and consequently came up with an original cartoon concept for yourself. It's akin to squinting at patterns in wallpaper or in the tiles on the bathroom floor. Sometimes you can perceive a face or a figure in those abstract shapes. But if you wait a second, tilt your head, and look at it differently, you'll see some other shapes.

This time let's draw a character with a large nose.

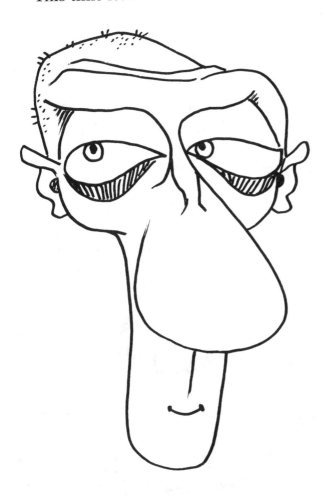

But now let's turn around and use the nose as the entire facial area, and the remainder of the face as his neck. We don't want to be bound by convention.

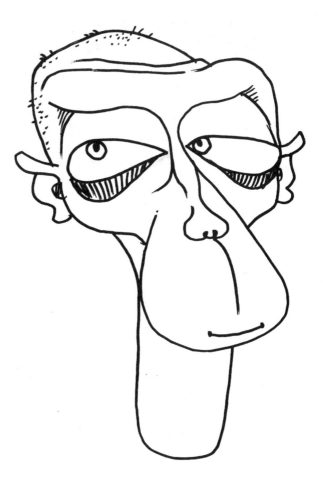

In this character I've placed the features in the upper half of her face and given her a generous chin.

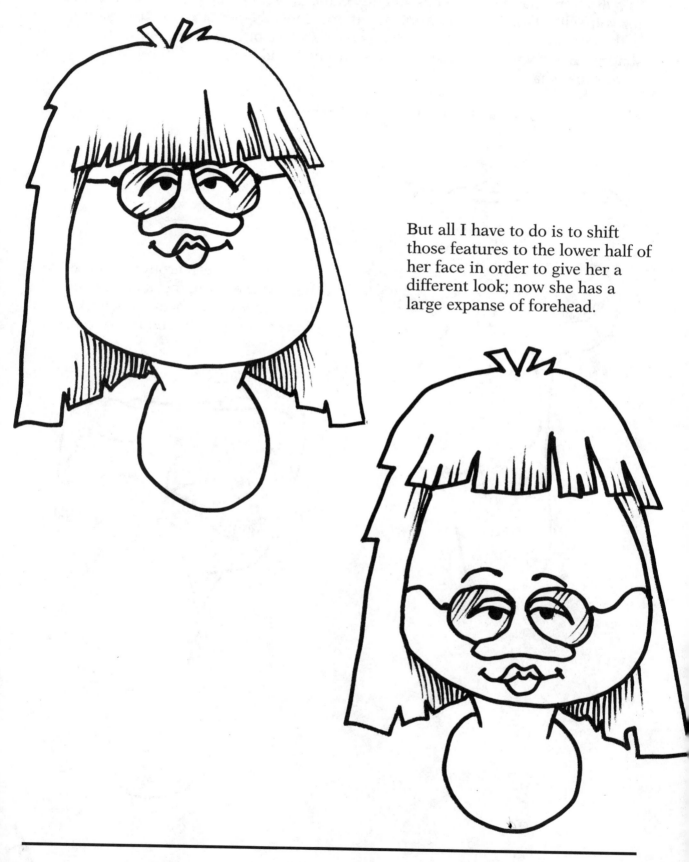

But all I have to do is to shift those features to the lower half of her face in order to give her a different look; now she has a large expanse of forehead.

Some of this may seem rather basic to you, but you'd be amazed at how many artists ignore the obvious and keep returning to the same configurations over and over again. That old axiom about going back to the basics now and then to refresh yourself really applies here.

Now this guy has a flat, wide nose.

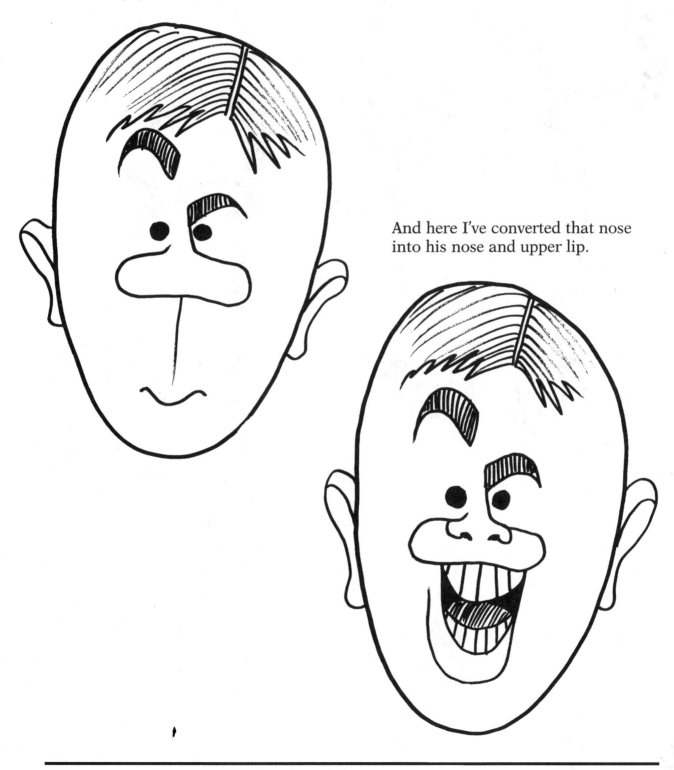

And here I've converted that nose into his nose and upper lip.

Okay. Your turn. Try shifting things around and playing with the areas in these two faces.

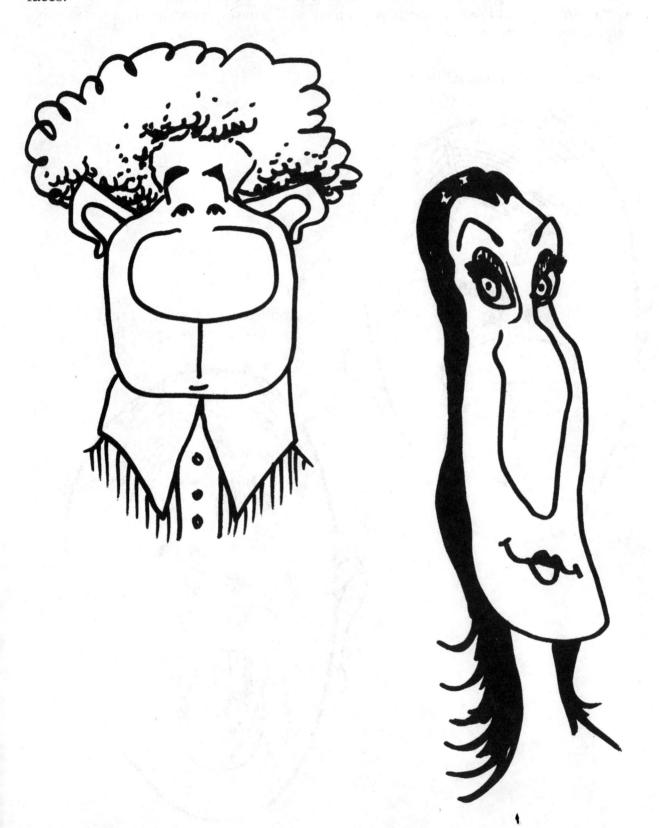

How about this one? Draw a head and sketch in a centrally located nose and eyebrows.

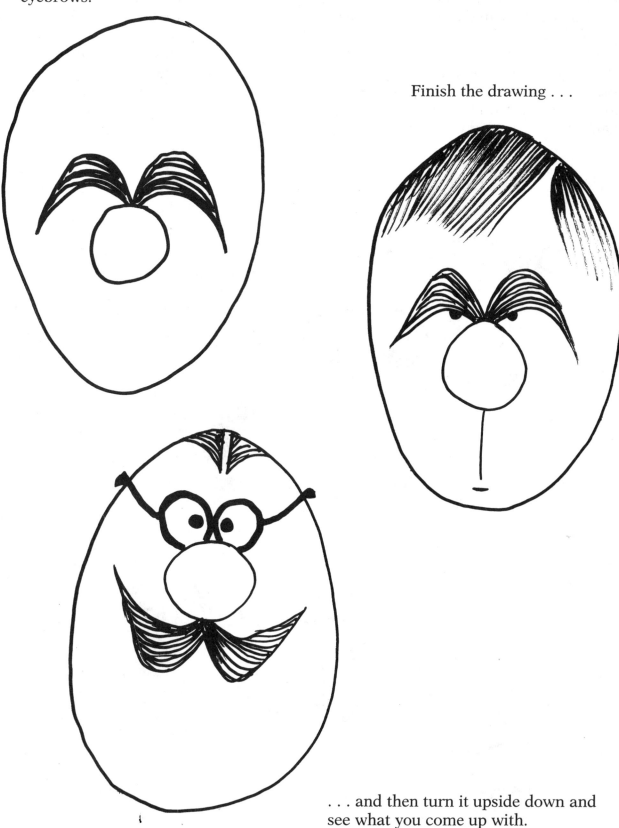

Finish the drawing . . .

. . . and then turn it upside down and see what you come up with.

A screenwriter I know writes all of the scenes for his movies on 3x5 cards sequentially, and then he does the oddest thing—he shuffles them like a deck of cards and deals them out in rows to see what random combinations appear. It doesn't always work, but on occasion he'll discover some relationship or juxtaposition of scenes that linear thinking didn't supply. I suggest almost the same thing with features and faces. Draw some features on some small cards, draw a large face enclosure, and then move the features around by hand until you come up with something you like. Or take these features and place them as you wish in whatever combination you desire in these spaces.

Here's a few assorted features. Some noses.

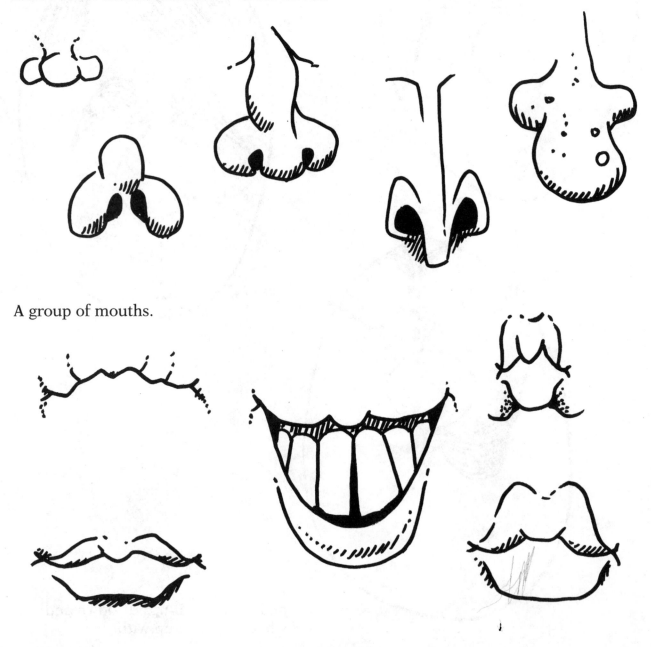

A group of mouths.

A few eyes.

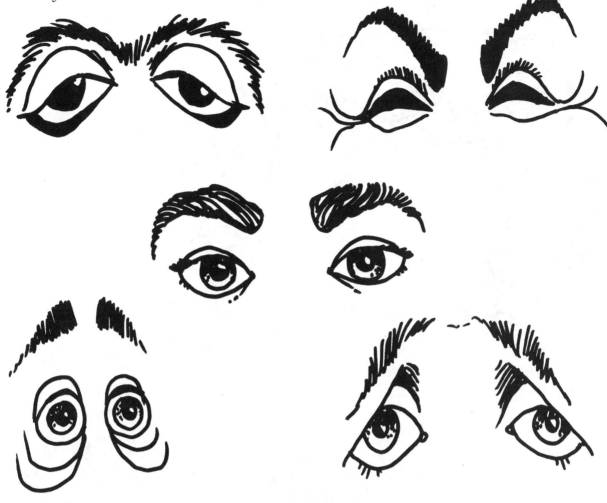

A couple of mustaches.

Some glasses.

And a few varieties of hair.

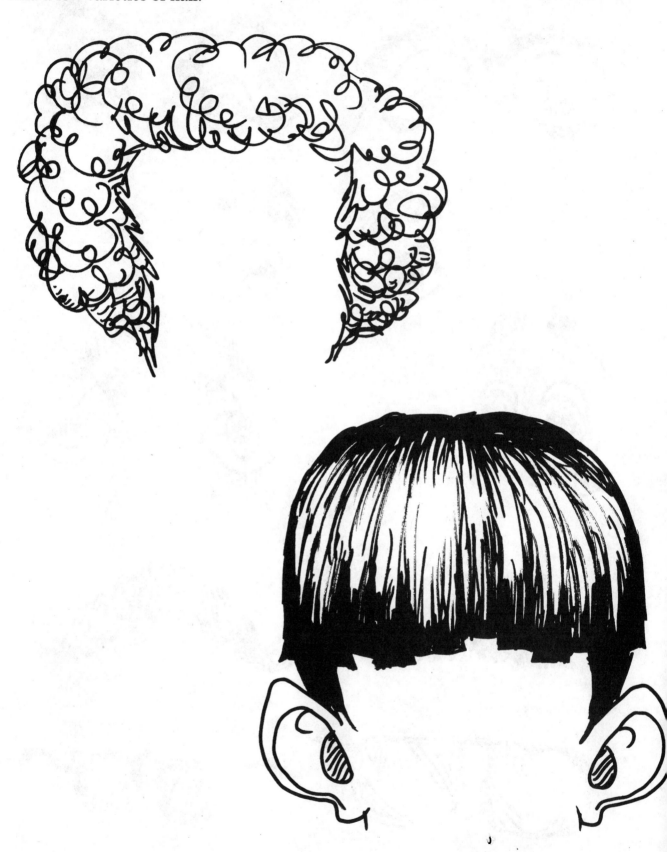

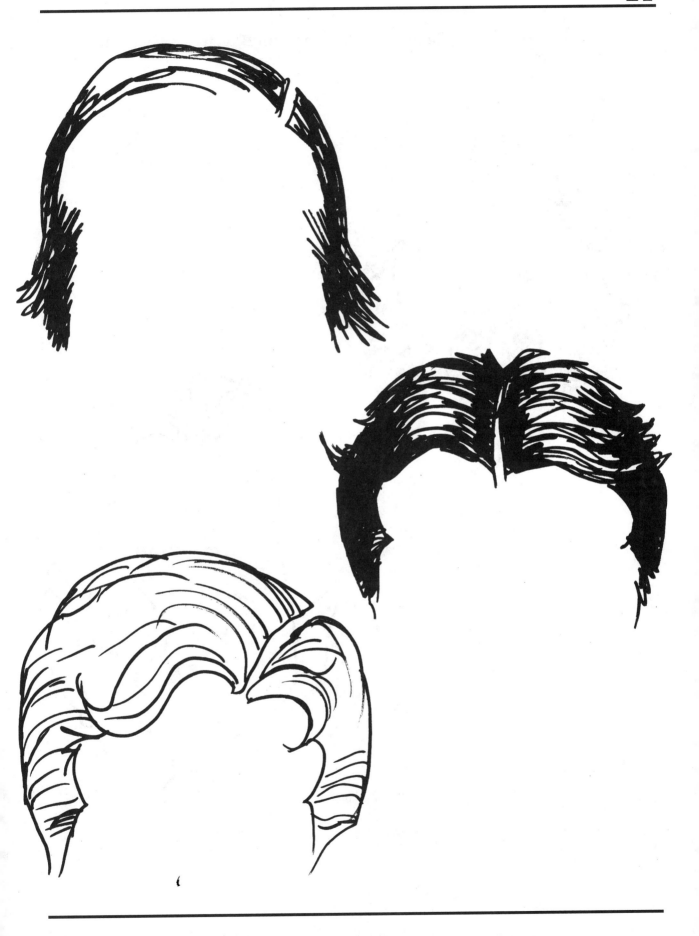

Now let's play a "one from column A, one from column B" game by combining these features in various ways.

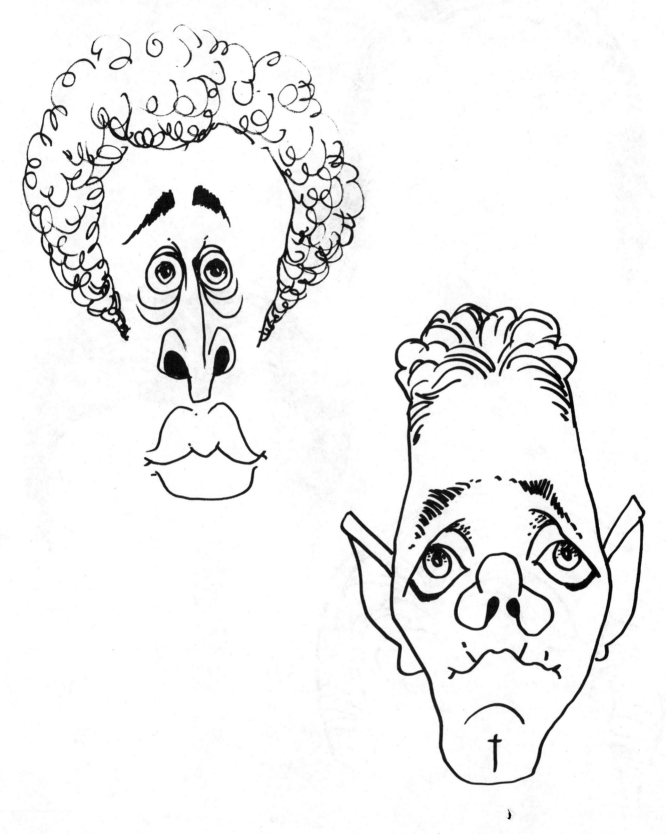

Now encase one grouping in different head shapes and add some hair.

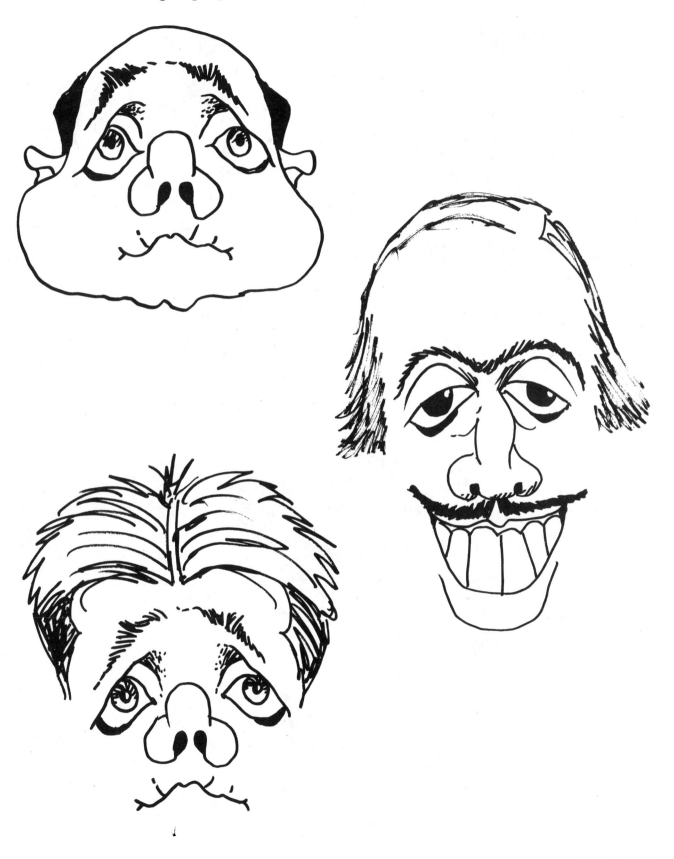

You can see the endless variations available to you.

Here's a face that I've enclosed in several different head shapes just to demonstrate how radically it can change the character.

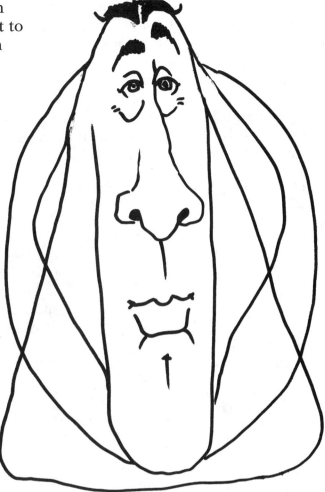

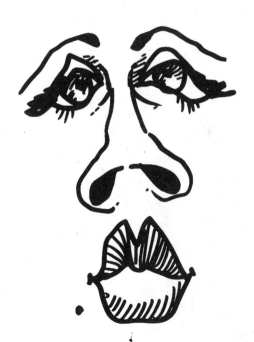

Your turn again. Take these female features and place them in a variety of head shapes (and while you're at it, try some different hairdos just for fun).

The key to all of this is to go out of your way to do things a bit differently from what you usually do. If you usually draw men, draw women, and vice versa. Be intentionally asymmetrical. Make one eye squinty and one round. Give a character a raised skeptical eyebrow or a crooked smile. In other words, try anything to shake up your pattern and start breaking it down.

Now let's try something else—an improvisational face, one that's totally unplanned or thought out. We have to start out with a single feature; we won't even worry about the head shape for now.

Let's begin with a nose. Will it be wide, narrow, flat, pug, or what? Make the decision.

Now think of the bridge of the nose as a clothesline upon which you will hang the rest of the features, and attach a pair of eyes—but first there are choices to be made: Large, small, almond-shaped, set close or set wide? Bagged or not?

I went for the bags. Now the brows: thick, thin, arched, straight . . . whatever.

Each step in this journey requires a small decision, and sometimes you'll surprise yourself.

Now jump down to the philtrum (that small indentation below your nose in the middle of your lip). Use that as the span to the mouth. Wide, full-lipped, toothy, pinched? Are the teeth even and white or crooked and yellowed? Do they have a diastema (that rather large gap between the center teeth a la David Letterman)?

And let that lead you to the chin . . . lantern-jawed, slender, pointed, dimpled? I've gone for a strong lantern jaw and a dimpled chin.

Now what? How about the hair—the frame for the face. Bushy, sleek, or none? I added a couple of small ears and we're done.

Now the rest is just embellishments. Beard, mustache, glasses, wrinkles?

Okay, now it's your turn. But this time start out with this chin and lower face. See where it takes you. Are the eyes going to be small and squinty or large and luscious? Will the mouth be generous or mean? Pay close attention to each decision you make along the way—each one directly influences the character you've created. Each twist and turn can provide a new and amusing character. Now start your way north and see what wonderful things await you.

The combining of abstract shapes makes for another form of stimulating art play; some artists actually compose their paintings with a series of carefully arranged circles and blocks and/or amorphous shapes before they even choose the subject matter. You can use this device as an impetus to creating highly original characters.

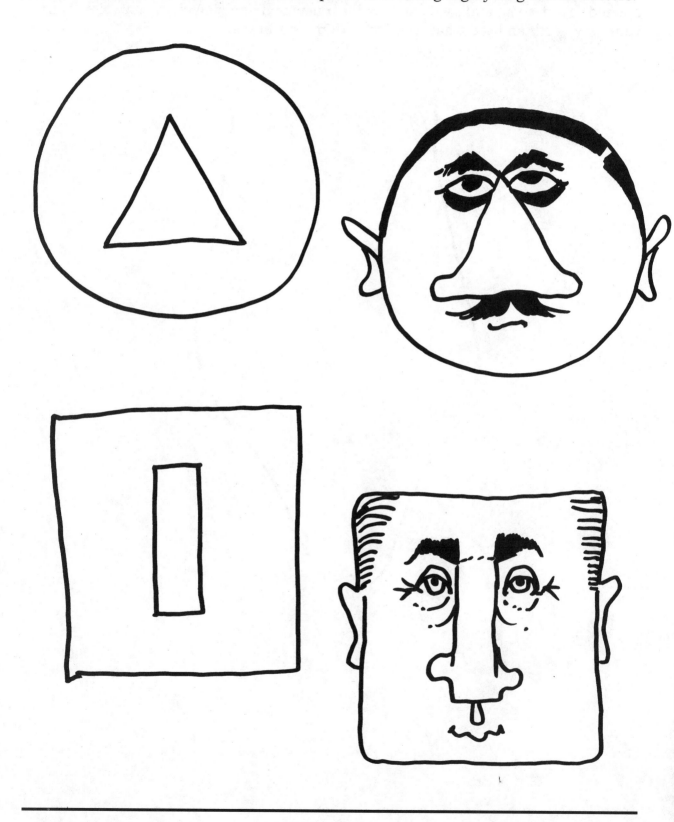

Here's another idea that I find fun and fascinating—take this front face with prominent ears . . .

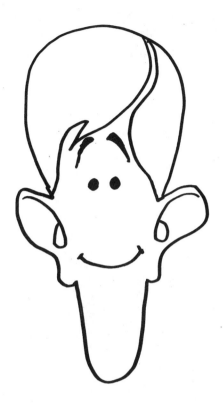

. . . and just use the outline . . .

. . . and split it vertically in half.

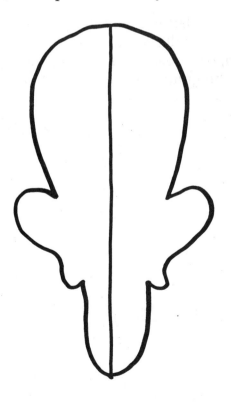

Now change your perspective so that each
half becomes a profile. Okay—what can we
do with this right half?

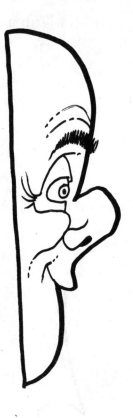

Let's take the left half and turn it upside
down, which will produce yet another
variation, or at least trigger an idea for you to
do something different with this character.

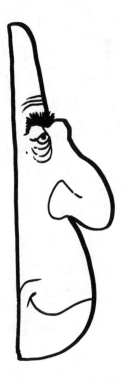

I even like to play the "scribble game." Have your friends or family scribble meaningless shapes on a piece of paper (like I've done here). Try to find faces in the shapes. Here are a few of my more successful tries (I'm not including the failures, do you think I'm nuts?).

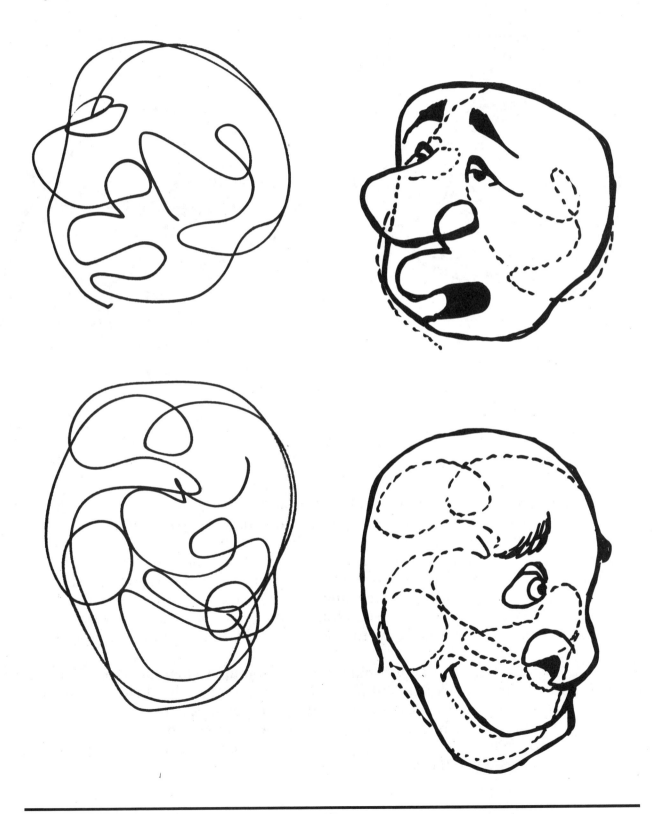

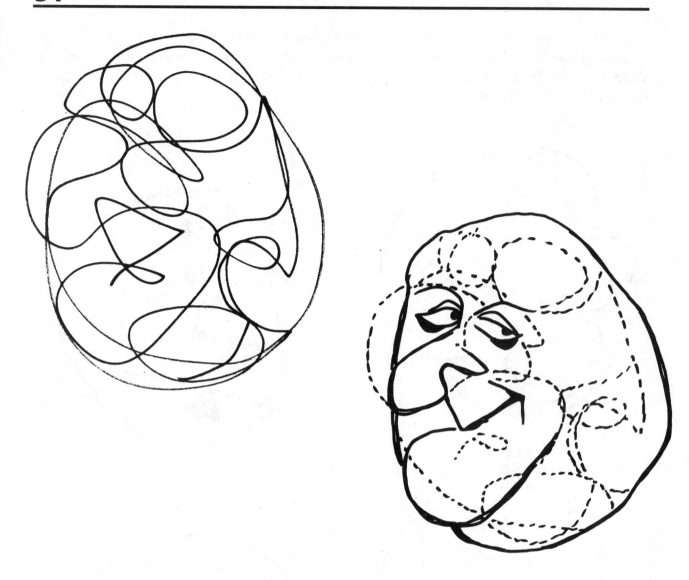

There's another technique for breaking blocks that I enjoy: it's difficult to demonstrate here so I'll do my best to explain it to you. Once you've finished drawing a character, place the face beneath a sheet of semi-transparent paper such as vellum. Now trace through the nose, for example; then, instead of leaving the drawing where it was, shift it around slightly until a different spatial relationship occurs. Shift and trace, shift and trace, and soon you will have come up with a fresh arrangement of features, ergo something much more original. It's really fun and an interesting way to come up with some highly different characters.

As you can see there are myriad techniques to free you up, to maintain your interest while you're learning and experimenting. These are just a few that I came up with. I'm sure that you're more than capable of finding your own devices and seeking out your own artistic tricks to help loosen yourself up. Continue to pursue and play with these, and while you're doing that you'll have to excuse me, I'm moving on to the next chapter. See you there.

The Artist As Thief

Let me state categorically right here and now that I believe in stealing. I like to steal features from one person and impose them upon someone else's face or combine them with others. I've been known to swipe a particularly fascinating nose from my doctor and jam it onto the head of my handyman. Or take my plumber's hair growth pattern and use it on my uncle. Or my aunt. There are no rules or limitations. Sort of a Garanimals, mix-and-match idea.

Just look around you—there are so many millions of variations on the human face and form. Borrow and integrate them into your creative process. Novelists admittedly borrow characters and stories from their personal experiences all the time, so why not the artist?

Keep those eyes peeled (one of the more painful sounding clichés) at restaurants, the waiting room in the doctor's office, the airport, or wherever—there's always yet another surprising facial variation that you might not have thought of.

Or, to pursue this game even further, how about drawing our inspiration from other sources, mundane sources that have distinctive unusual shapes; a slice of bread, for instance.

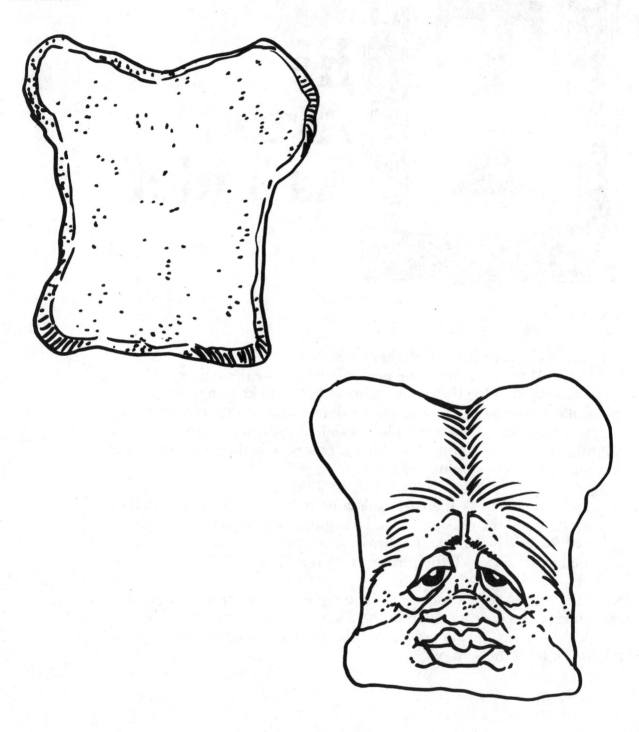

It works as a wonderful head shape for a character. I might not have thought of it without that inspiration.

A pear is always a good old standby.

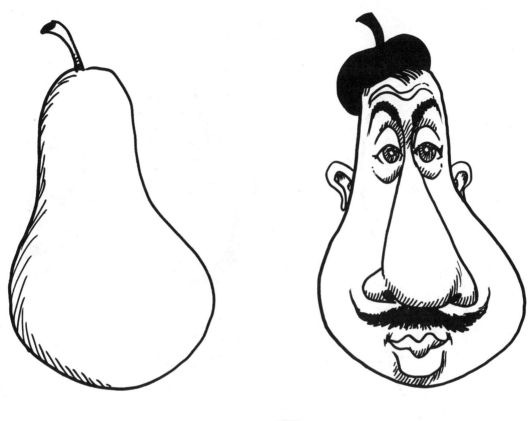

And of course we have
to turn it upside down.

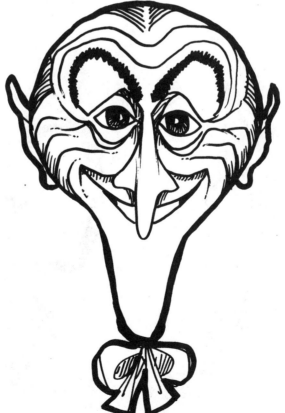

There are few shapes that can't be used as inspiration.
Even a shoe works.

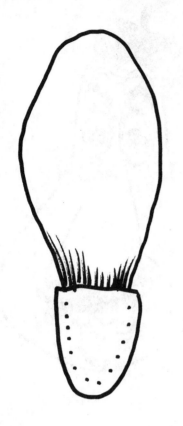

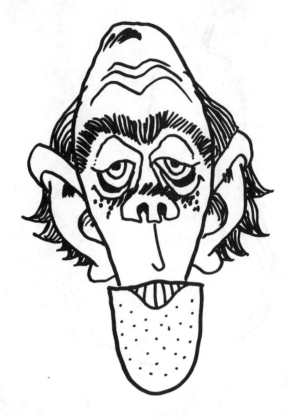

A bow.

A horseshoe.

A pretzel.

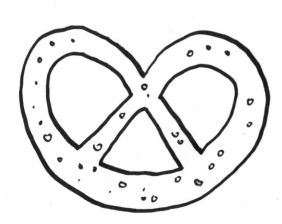 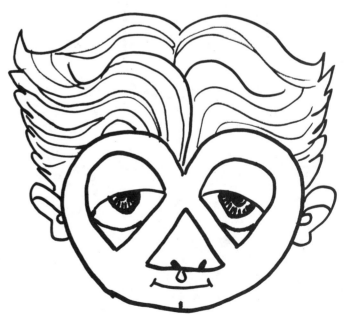

And a spoon.

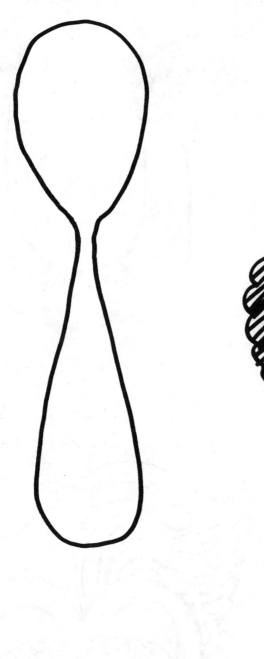

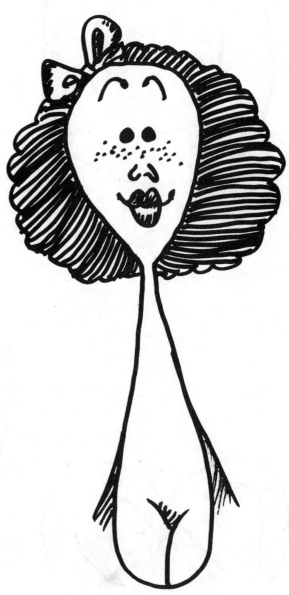

Now let's do something different with this spoon. Let's use it as the center of the face for yet another character.

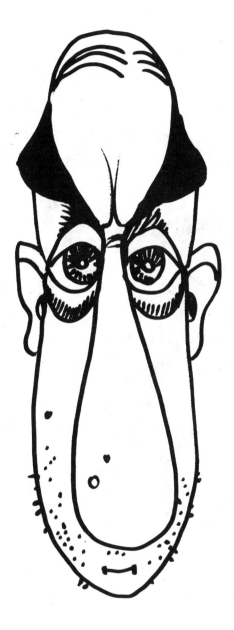

And let's use the spoon another way yet.

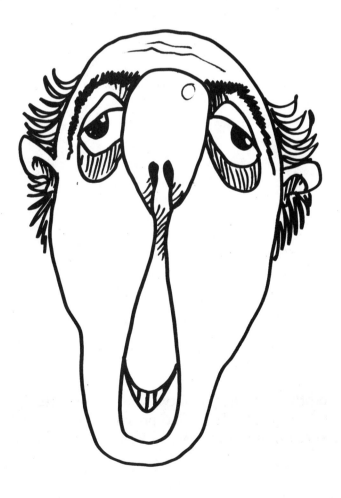

Nothing is exempt—not even a toilet.

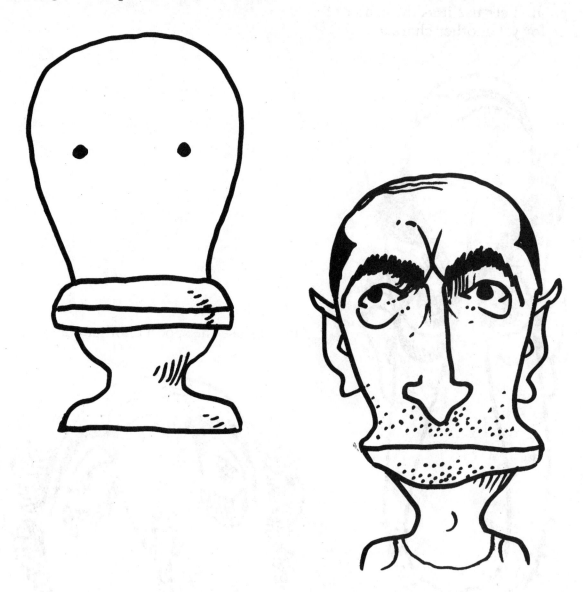

In other words, you have to develop a quirky eye—your own unique way of viewing the world. It's bound to provoke a host of interesting creations. So surreptitiously sketch it and file it away. Believe me, it'll come in handy someday.

Now, what else can we do when we dry up and run out of ideas? The world is chock-full of inspiration. Landscape artists search everywhere for that perfect meadow or picturesque waterfall, so on occasion we too have to look elsewhere for something that will precipitate creative play.

One of my favorite spots is the zoo. The animal kingdom has long served artists as an anthropomorphic playground, especially for animated cartoons; Bugs Bunny and others are certainly as human as they are animal, hence their appeal. We humans borrow from or are inspired by the animal world all the time. So let's take a few animals and use them as springboards to create some new characters.

Like this cocker spaniel.

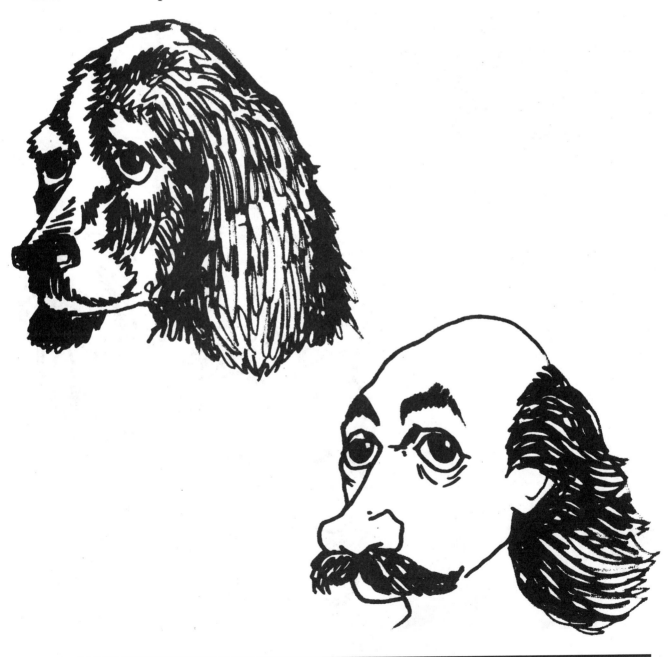

And this lion.

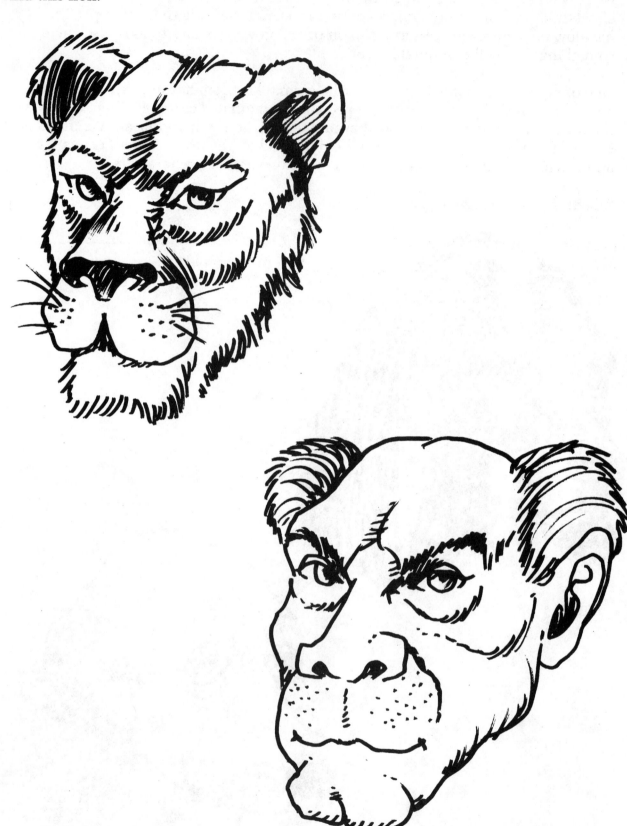

The frog lends itself to an interesting face.

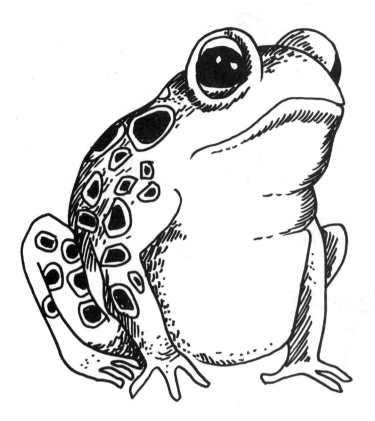

As does this elephant . . .

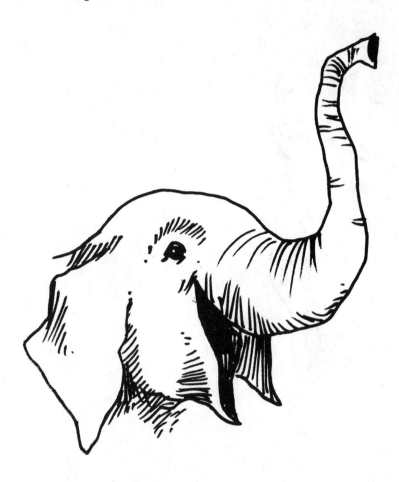

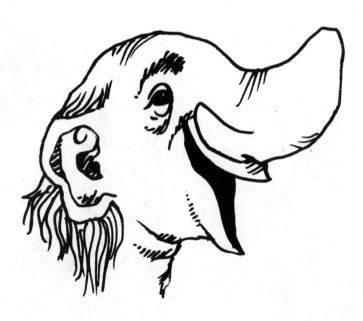

And of course the gorilla . . .

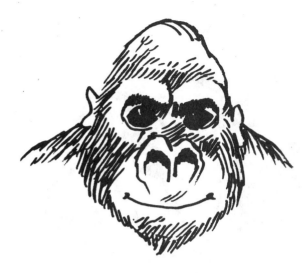

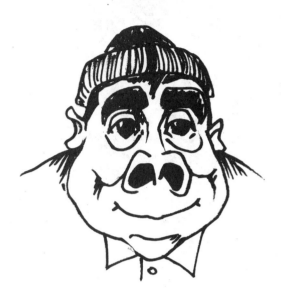

This silly-looking pussycat . . .

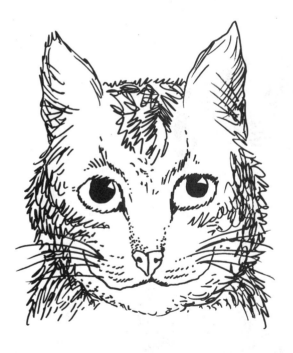

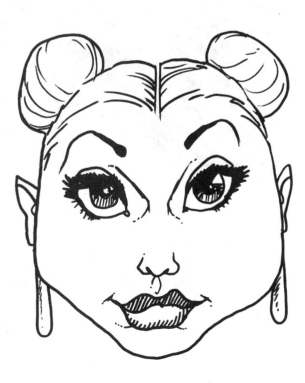

A bulldog.

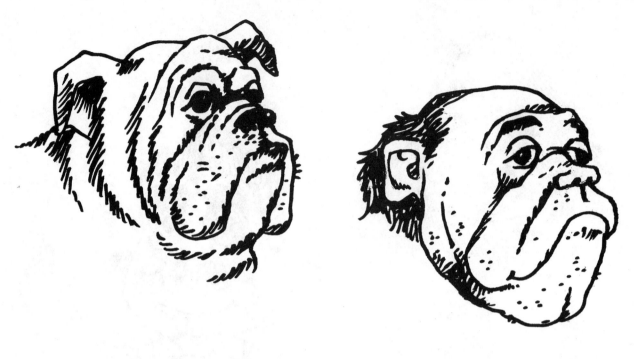

An eagle.

And an owl.

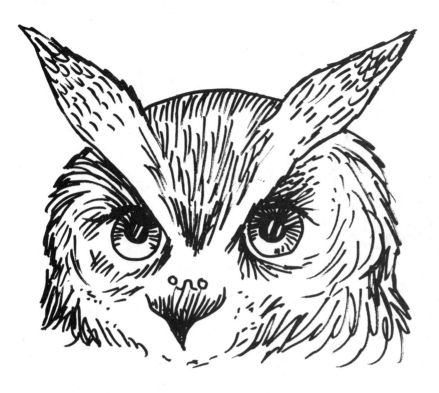

Okay, now it's your turn. . . . Take this tiger and this bear and use them as inspiration for some people faces. Incorporate whatever you can from the animal while still keeping it human.

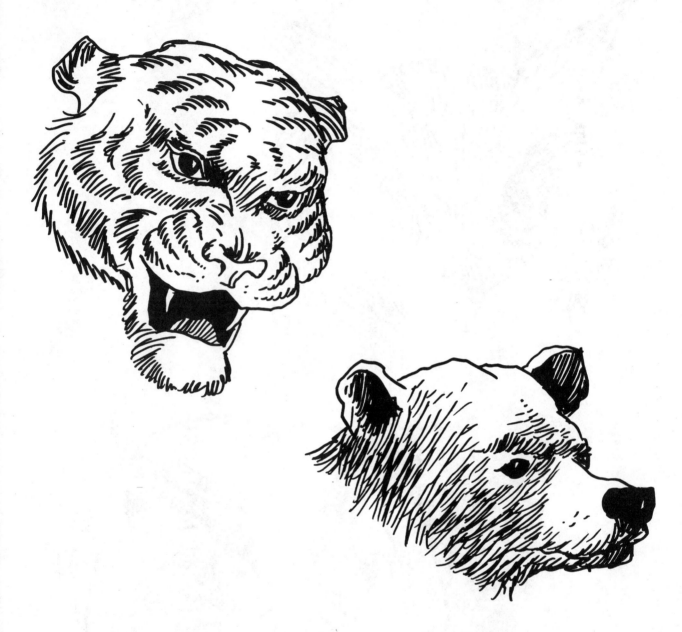

As you can see, there are many areas that can serve as inspiration for us. The old line goes something like "Steal from one writer and it's plagiarism, steal from many and it's research." So take yourself out to the zoo, to the library, to the park—sketch wherever, whenever and whomever you can. No face is sacred, everyone has some feature or flaw that can inspire you to greater heights. Look around you and find some mundane, everyday object that you can use as a springboard to cartoon play. And do it now!

Okay, enough felonious activity. Let's move along here.

Styles & Techniques (The Dynamic Duo)

There are many techniques that lend themselves to cartooning. In some cases an odd overlapping occurs: a particular technique virtually becomes the style. The horizons broaden even more when we step into the realm of "humorous illustration." Techniques are shaped partially by the instrument you prefer to work with—pen, pencil, or brush—and that's something only you can choose. It's often simply a matter of what feels comfortable in your hand. I prefer pen, and although I enjoy a fountain pen, it doesn't work for me. Why? I'm left-handed, so my hand drags across the drawing and smears it too often. Left-handed people are highly discriminated against, you know. The ring binders open on the wrong side, and, as if that weren't enough, we're referred to as "gauche" (French for left) and "sinister" (from the Italian *sinistre)*. But I digress—now that I have that off my chest, we'll continue. The pens I choose to work with dry quickly, like plain old Flair felt tips and Sharpies or Vis-A-Vis fine points. I personally prefer pen to pencil (I smear too much) but that's a matter of convenience. Since I occasionally like to sketch out in public, brushes are too unwieldy given all the supplies needed. Ultimately, you'll have to experiment to find the drawing utensil that feels most comfortable to you.

The pen, I believe, is hands down the utensil most used by cartoonists. It's neat, easy, and handy, and art stores carry an incredibly wide variety.

I like Penstix, as they come in about four different widths, and Micron Pigma. I also use Koh-I-Noor Artpens, Rapidograph, and for filling in large black areas I go to Marks-A-Lot broadtips. Then of course there's the Speedball series, with a pen holder and a wide variety of changeable tips. There are many wonderful fountain pens that can see you through a good hour of constant sketching without demanding refilling, like the aforementioned Koh-I-Noor and Rapidograph, and also the Osmiroid fountain pen series. I particularly like them because they come in left- and right-handed versions. Very considerate of we "sinistre" types.

The different styles you can achieve with pens are numerous. You can run the spectrum from this example of tentative, nervous lines (currently a popular technique in trendy animation) . . .

. . . to a broken line style . . .

. . . to a more casual approach.

Here are a few different ways to do line work.

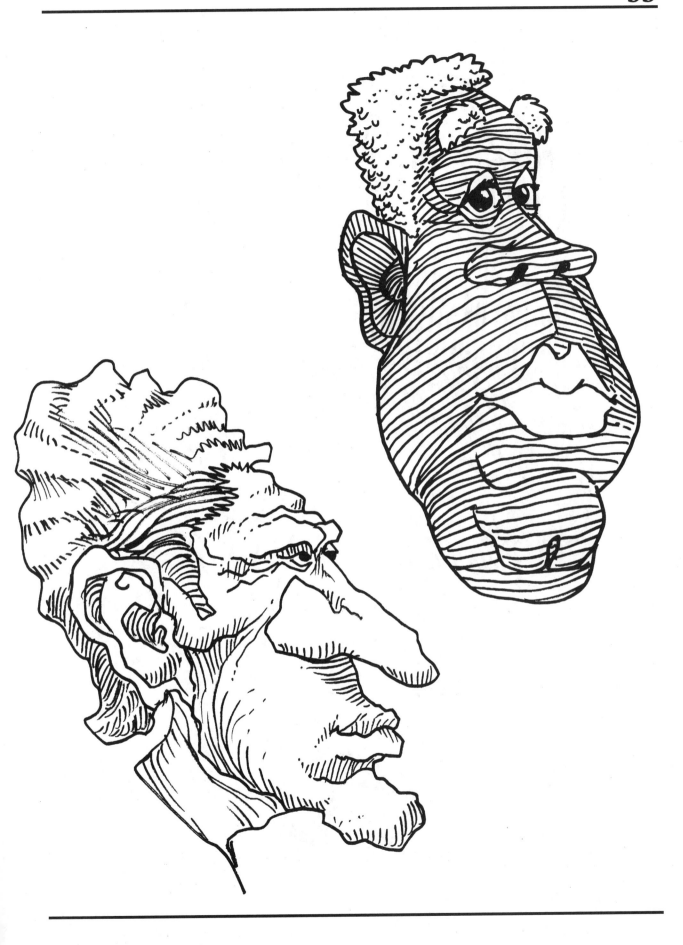

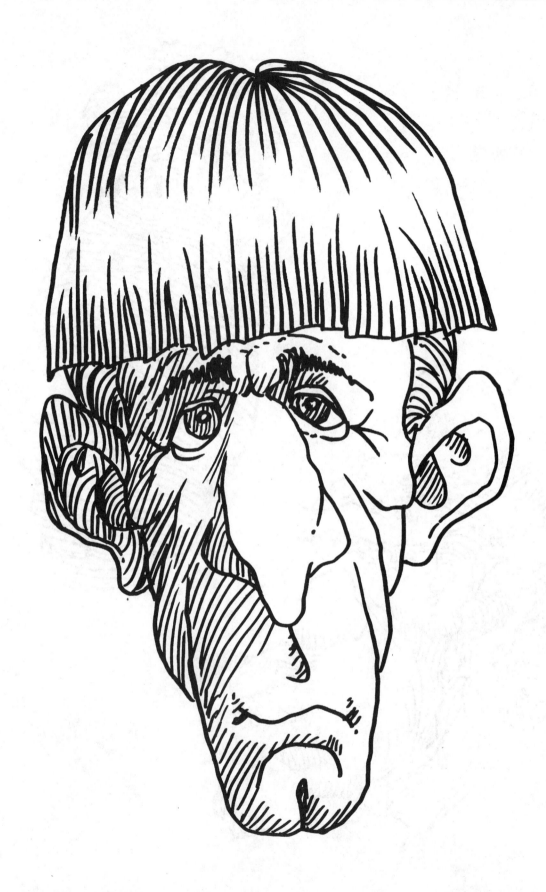

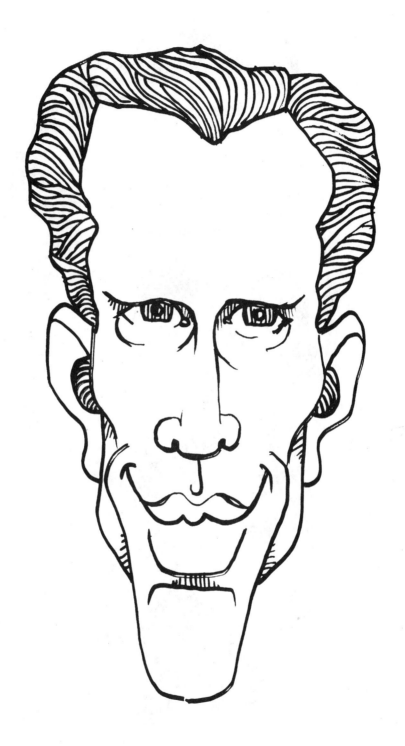

Or try your hand at crosshatching. First, a more delicate touch . . .

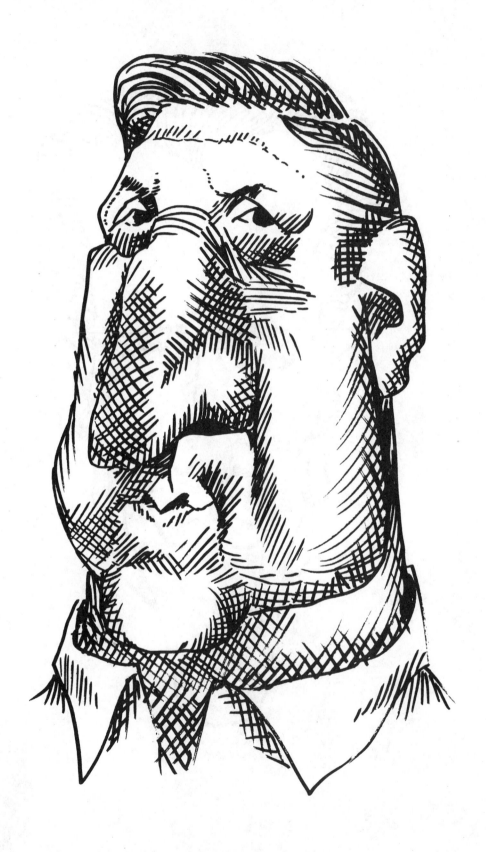

. . . and then a rougher approach.

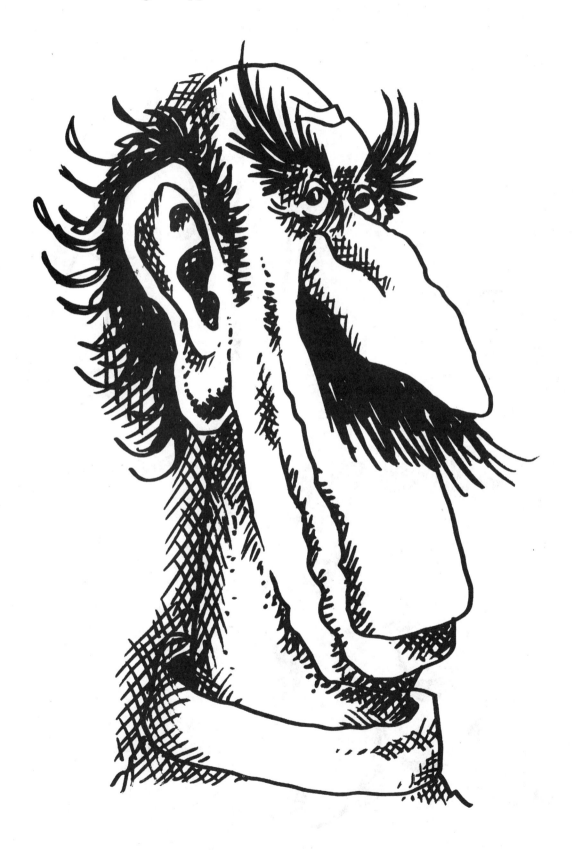

Here are some examples of thick and thin technique where the shadows form the contours and there's no gray areas at all.

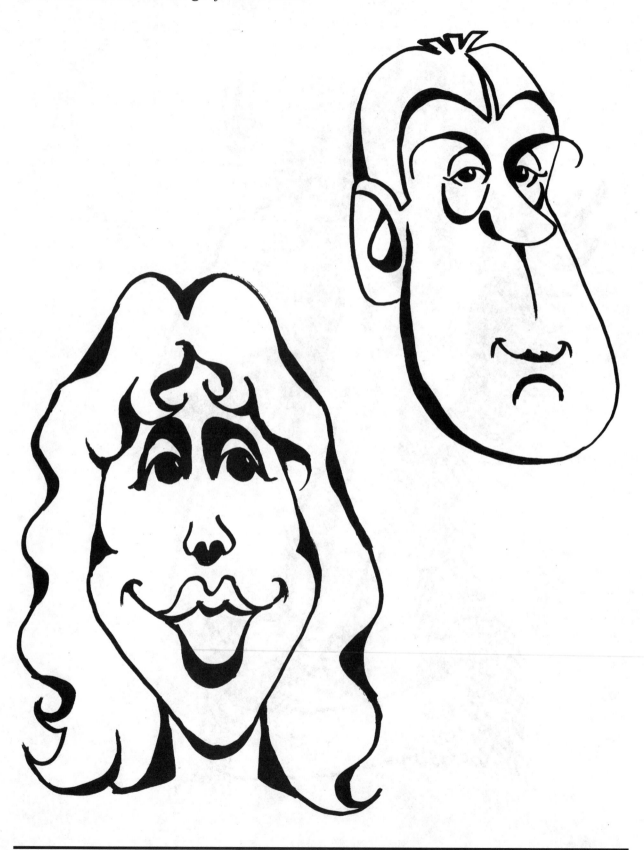

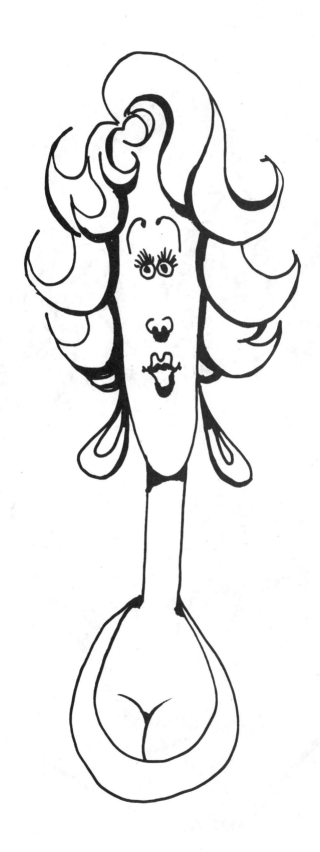

Stippling is the cartoonist version of pointillism. It can be used sparingly . . .

. . . as a more dominant style . . .

. . . or in combination with line work for a more painstaking technique.

I drew this guy with a finer pen point and then outlined him heavier for this effect.

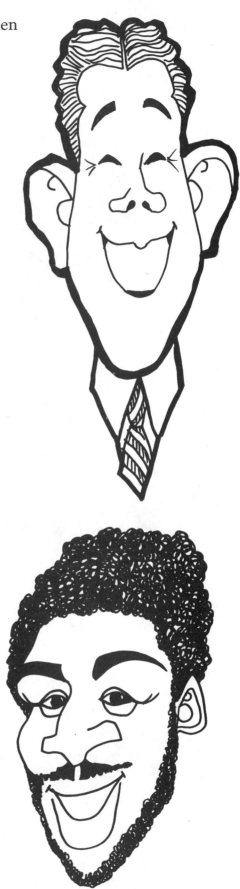

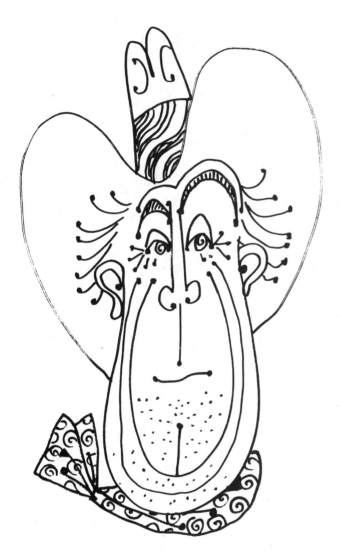

I did this cowboy in a highly stylized technique.

This man was done in a very clean style with simple lines to contrast with the tight scribbled hair technique. We'll discuss hair in more detail a little further on.

I also like to get down and dirty by using a Flair felt tip, wetting the tip of my finger and rubbing in some areas for soft shading. You can't wait too long—you have to do it as you go before the ink totally dries. Here are a few examples of this effective albeit messy technique.

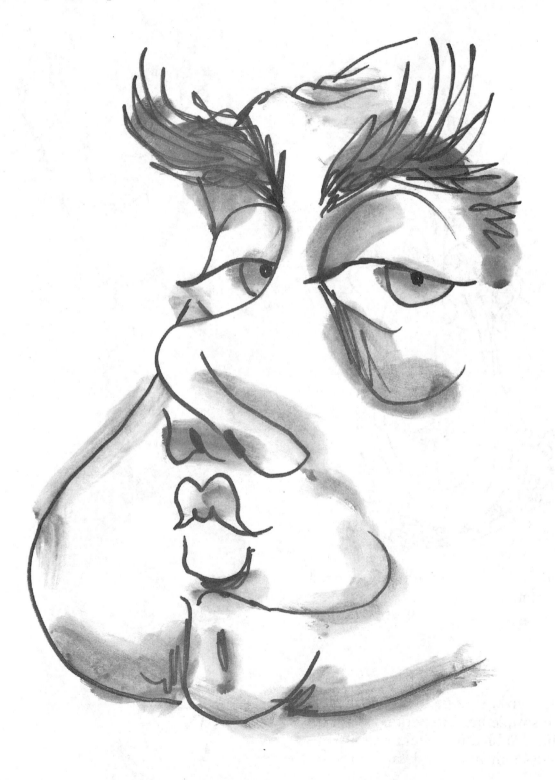

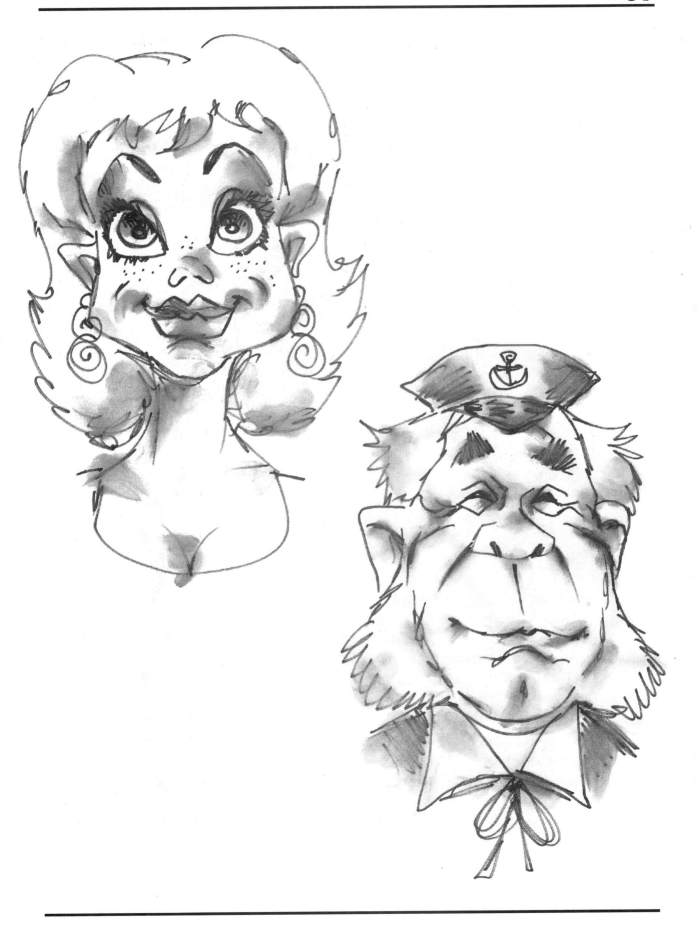

Brushes produce a much looser feeling. It's pretty tough to use a brush and be too tight or precise.

This woman was done with a No. 00 (fairly fine point).

For this one I used a slightly heavier brush, a No. 4.

And here's No. 10 for a bolder approach.

The other thing a brush does is to open up the world of wash to you. Wash is merely water with a few drops of ink added; its use in more sophisticated shading is invaluable to the cartoon artist.

Here are some examples of work in wash.

In this case I applied a light wash to a non-indelible ink pen drawing so that the ink smeared slightly as I worked with the brush.

You can also achieve a very unusual effect by pre-moistening the paper, then applying pen or brush and seeing what emerges. The paper has to be very wet and the ink must be applied quickly to achieve maximum results.

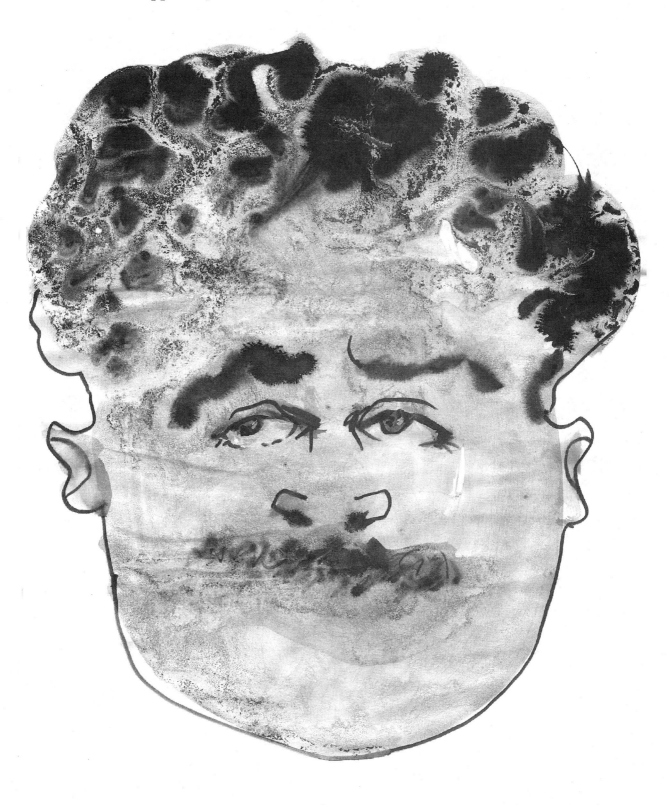

Pencils provide the opportunity to introduce a softer, more subtle feeling to your drawings, as in these two sketches.

Grease pencil possesses its own particular quality. It also has subtle gradations, especially on a rougher textured paper, but it's more opaque and consequently more intense than a soft lead pencil.

To achieve a really different look, mask off specific areas of a drawing and treat that portion with sponging or some other unusual (or unexpected) technique: it opens the door to many more interesting variations. There are several products available for this purpose; I like Winsor & Newton's Colourless Art Masking Fluid. It sets quickly, you do your work and then merely peel it off when you're done. In this drawing I used a sponge to fill in the eyebrows and beard.

On this one I went for a cheap airbrush technique (dipping an old toothbrush in India ink and fanning it with my thumb).

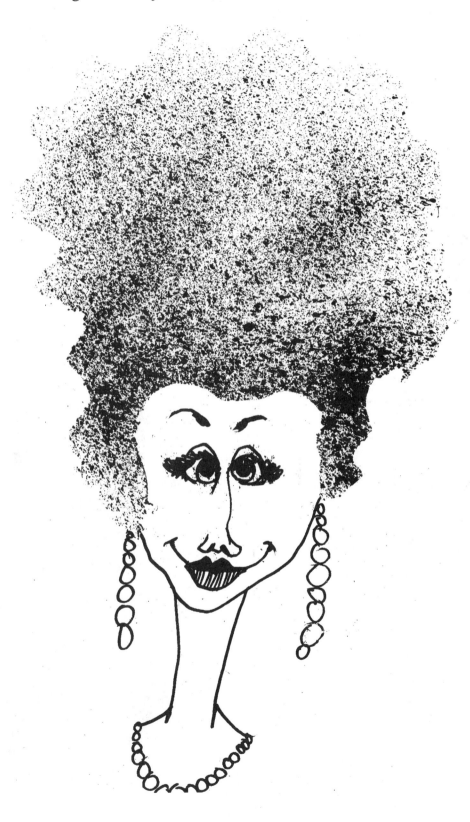

Mechanical tints (formerly called BenDay after its inventor, Benjamin Day) are terrific for certain projects. The designs are endless, and every pattern that you can imagine—check, plaid, herringbone, dot, spot, and blot—is included in these voluminous catalogues. You might as well avail yourself of them; they're simple to use and they'll produce terrific looks for your drawings. Here are some drawings before and after I applied the tints. Some mechanical tints you cut and press on while others (which I personally prefer) you burnish on with a wooden utensil. I find that I can control the latter a bit better. These tints really can spruce up your drawings.

Here are a few sketches before and after the use of these tints.

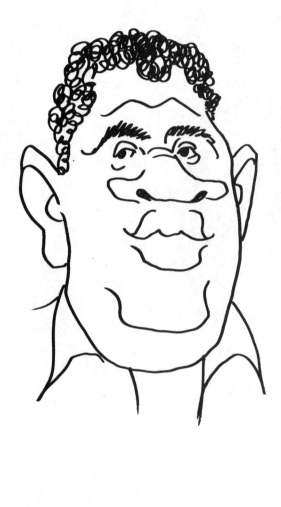

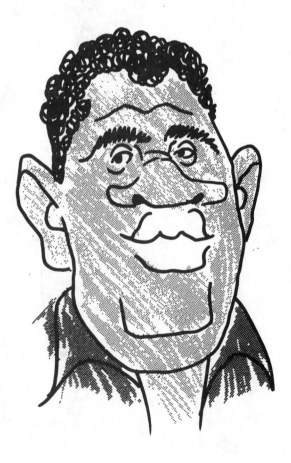

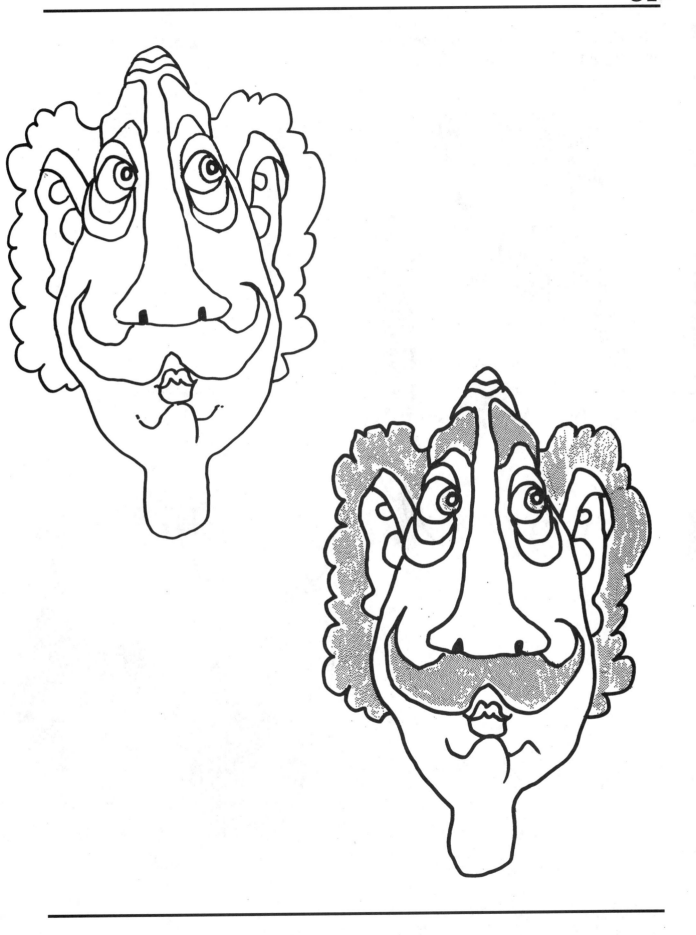

So invest in a few sheets and experiment. They're not too cheap, but it'll be well worth your while . . . and it's fun!

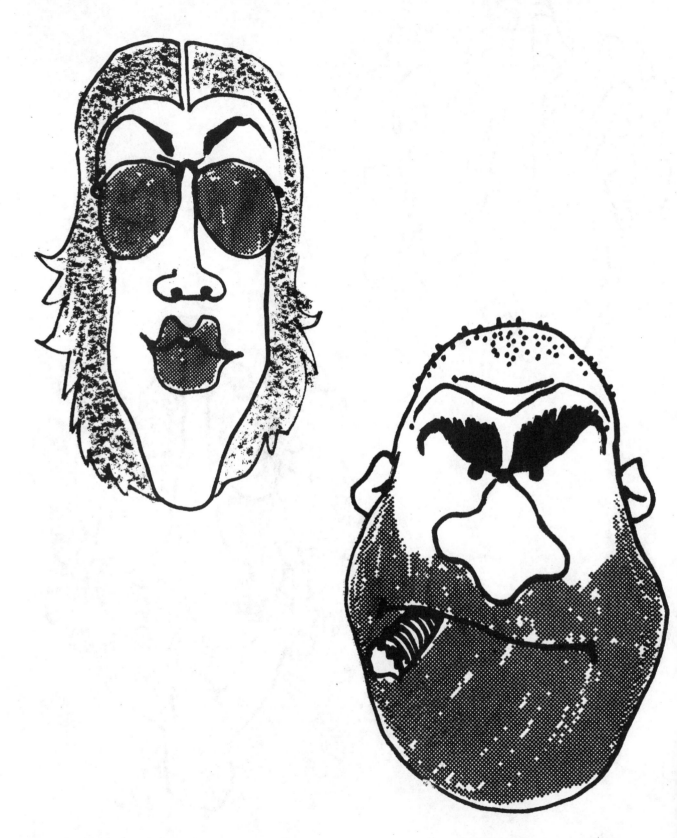

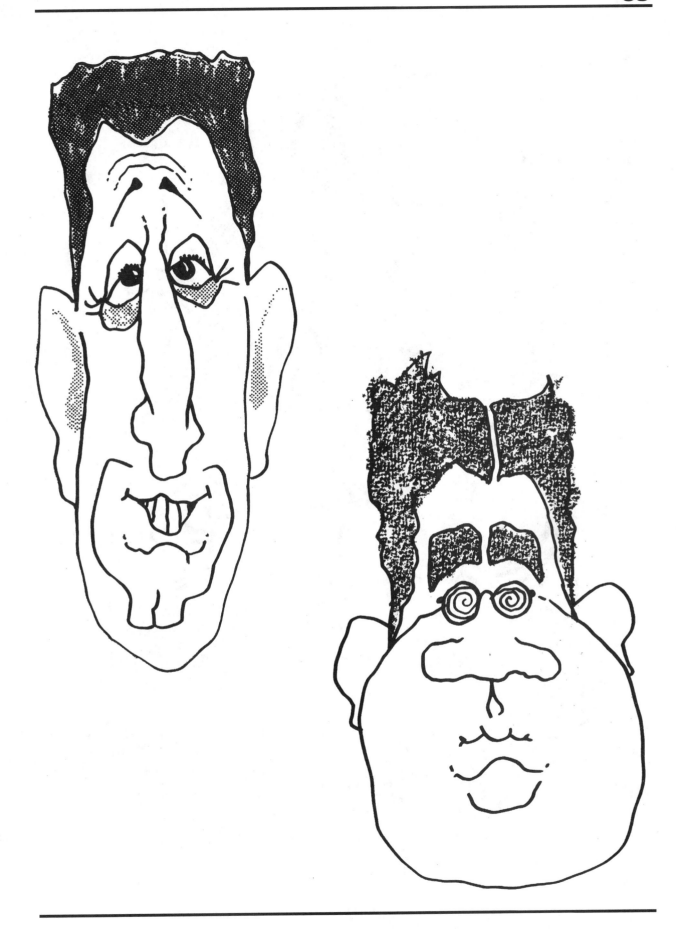

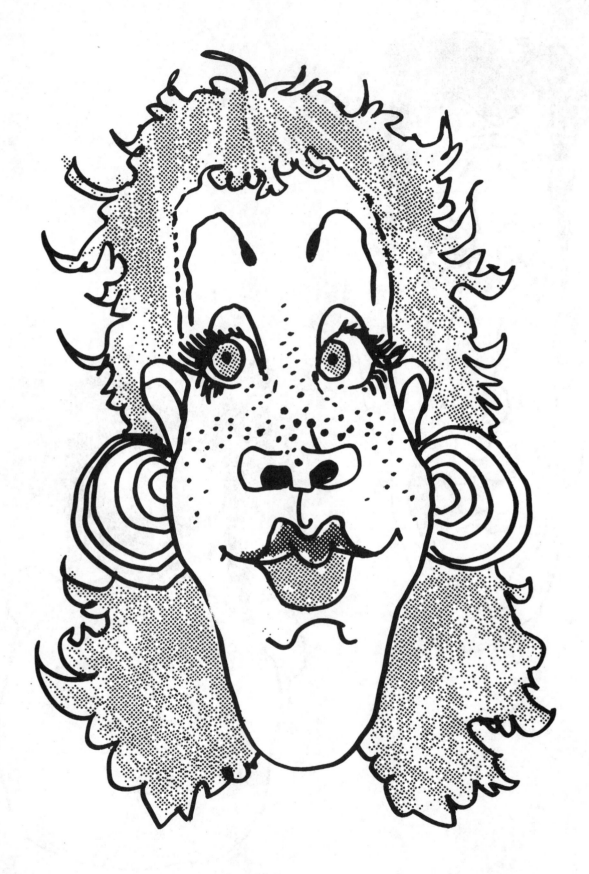

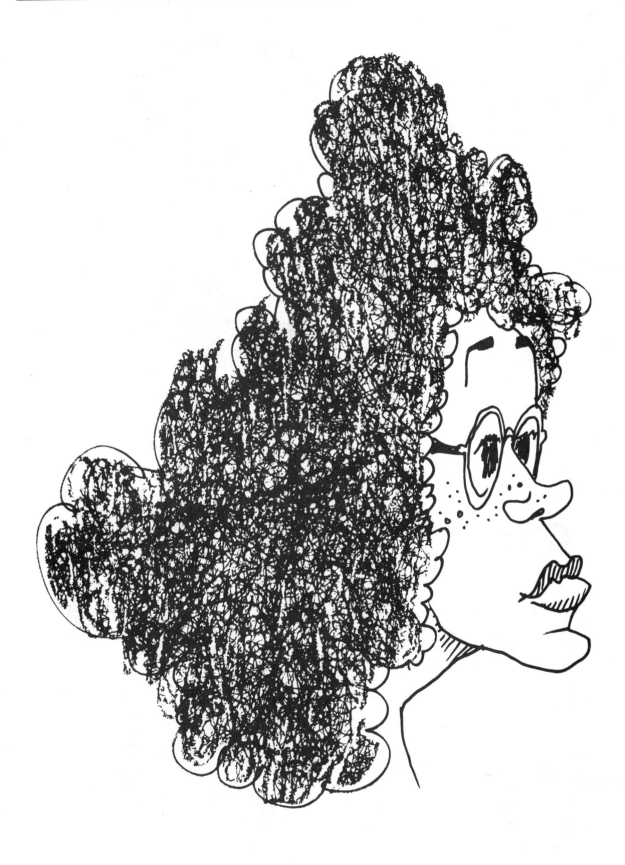

To do a quick recap on this section, just so you can see the various techniques and how they can be applied to one drawing, here's an Abe Lincoln sketch that I did with a brush . . .

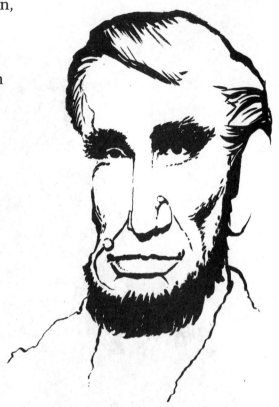

Then a pencil where, as you can see, there are more nuances.

Here I used a subtle wash.

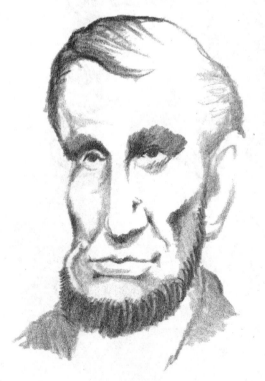

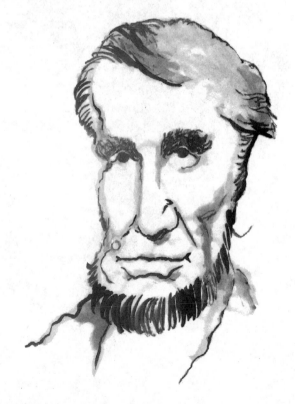

I used a pen to achieve this vertical lined technique.

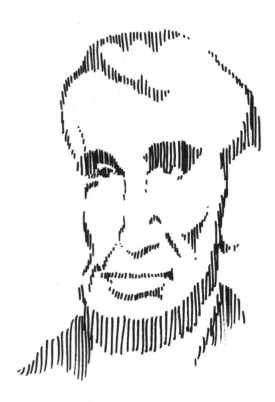

Here's a grease pencil version of the same drawing.

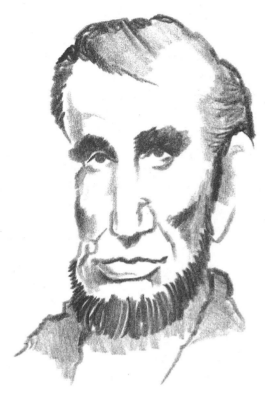

This is a very casual pen style where I hardly lift the pen off the paper.

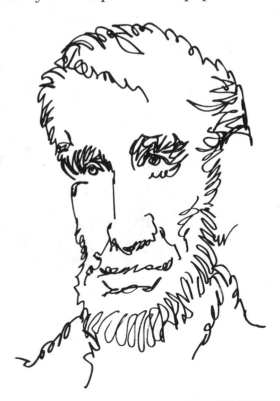

And with this version I used mechanical tints.

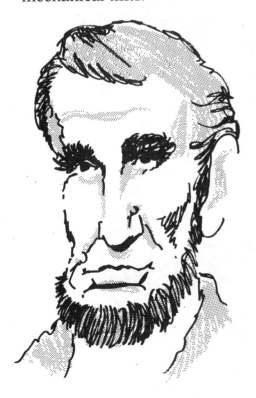

Cartooning has so many varied incarnations, its styles run the gamut from childishly simple to painfully elaborate. I'm going to demonstrate a few of these styles so that you can see the wide range of possibilities. Most of these characters were inspired by (not copied from) the Sunday funnies, which I consider to be a fair cross section of cartooning styles. Maybe one of the approaches will grab you viscerally and inspire you to say, "That's the kind of cartoonist I want to be." Much like the TV viewer who watches some show and says, "I can write better than that," and finds a career, I think that sometimes the creative shaping process has to be triggered by some intangible force, something that impels us to be attracted to one picture as opposed to another. This doesn't mean that you are copying or stealing, it merely means that a particular style appeals to you and you want to emulate (not imitate) it, and use it as a stepping stone to your own indelible signature within that style. They run the gamut from the cute to the silly to the naive to the more realistic "soapy" strips.

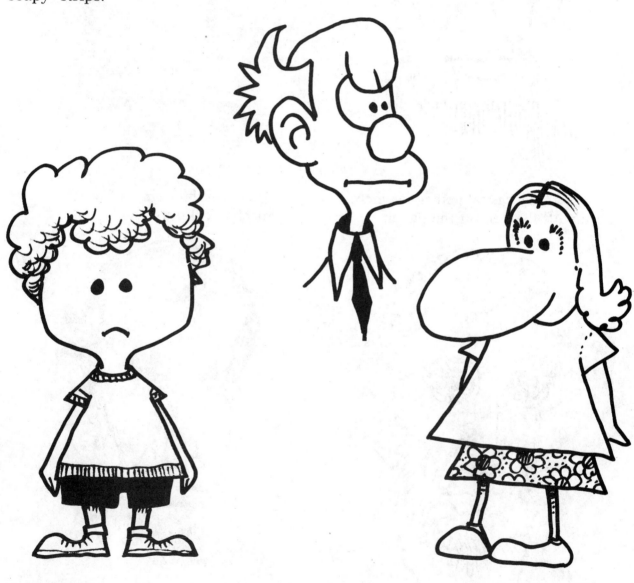

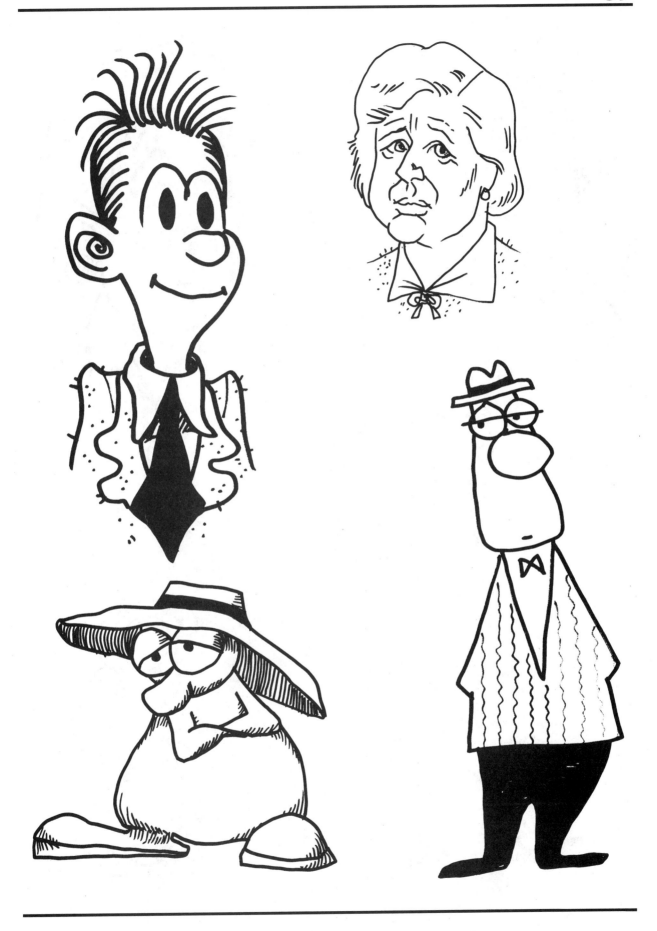

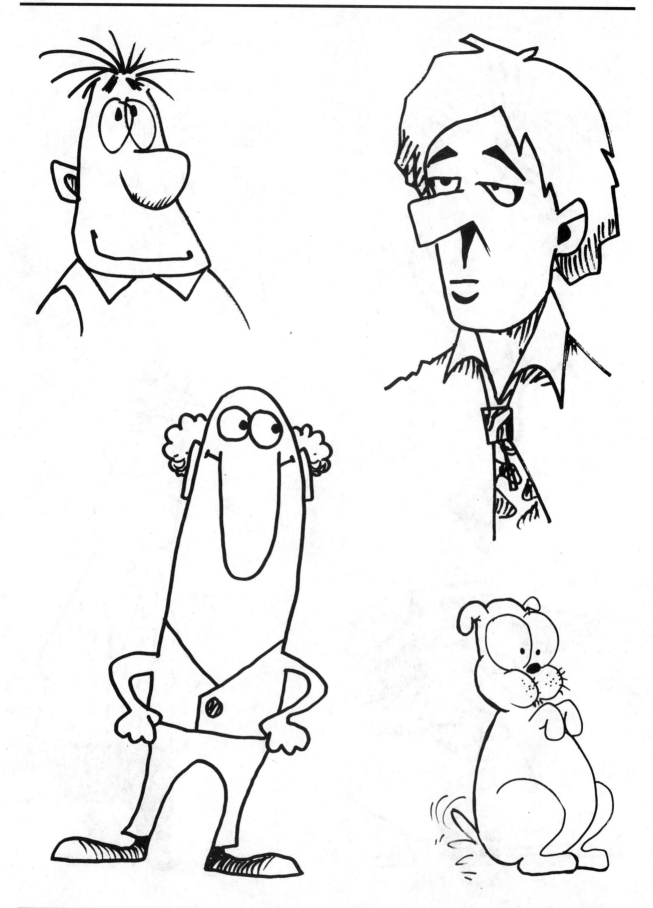

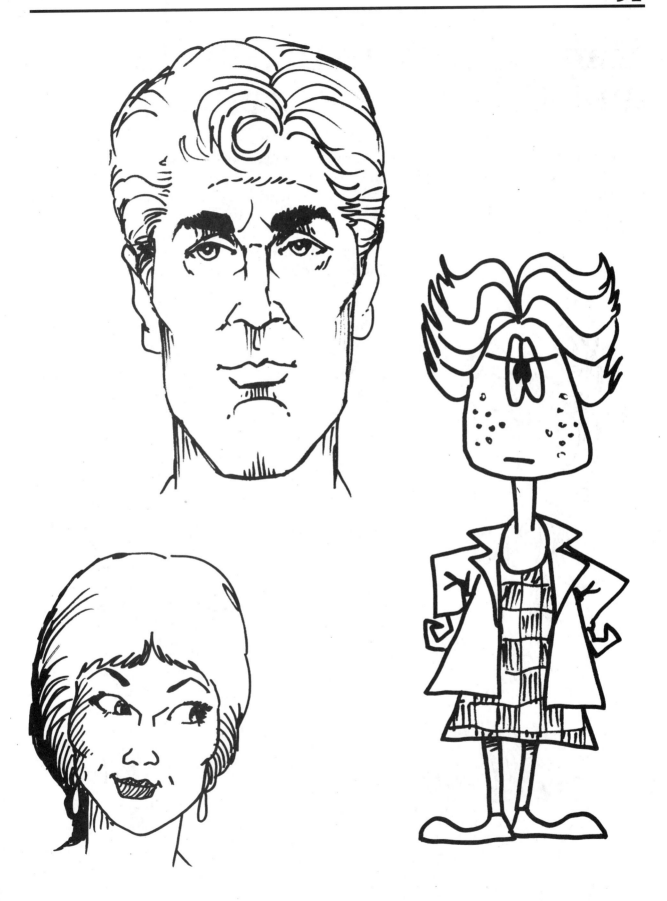

Hair-Dos, Hair-Don'ts, Duds, and Other Accoutrements

I've received a mess of questions about drawing hair, so let me respond by saying that there are simple and complex ways to draw hair. You can handle it painstakingly strand by strand or merely suggest it with a few deft strokes; you can scribble it in or fill it in solid. Here are just a few ways to do hair. Practice each style so that your hand becomes accustomed to the control necessary to achieve these different looks. True, you may never use these, but the more ammo in your arsenal the better. You just never know what you'll be called upon to do.

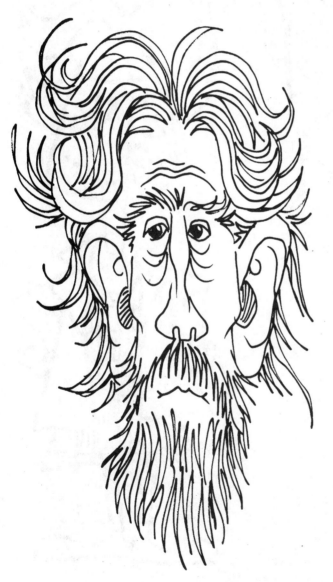

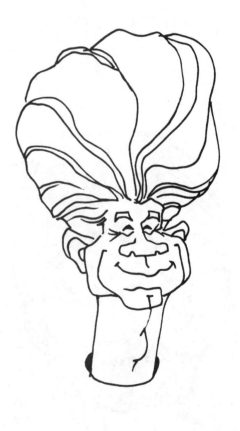

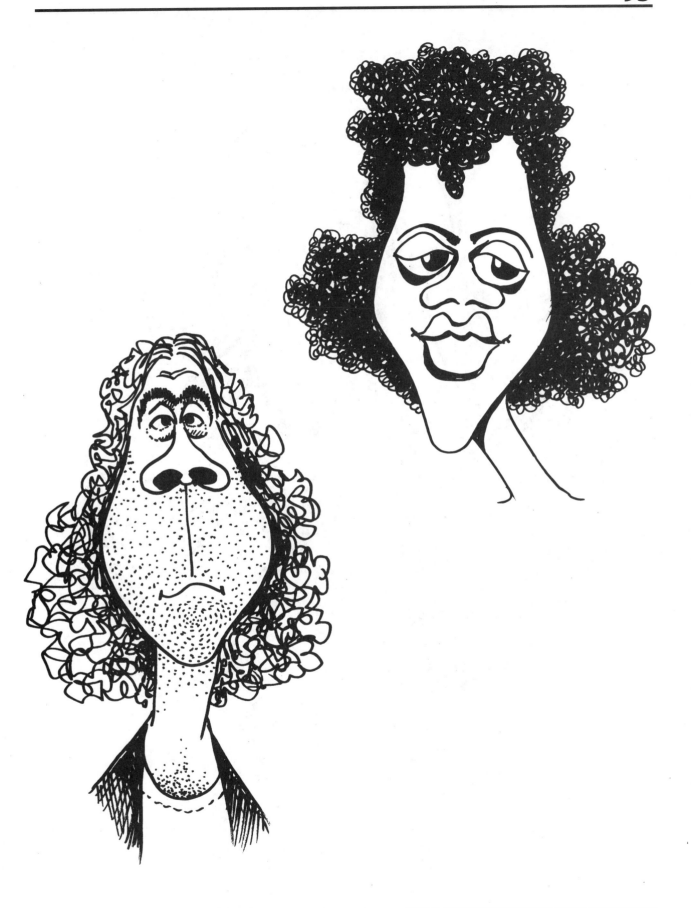

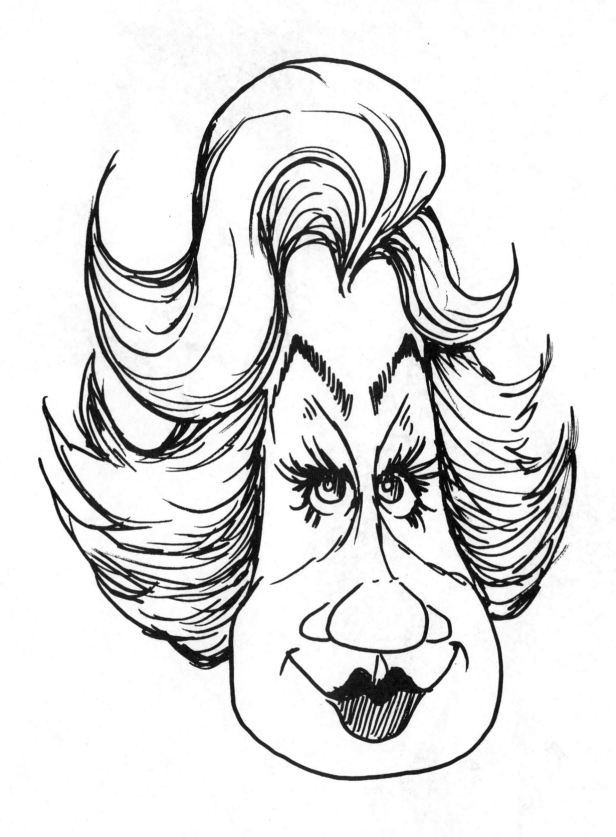

Here are a couple of hair treatments combined with those tints we were just using.

And here's "spaghetti hair" for those of you who haven't anything better to do with your time (like me, I guess).

Somewhere in there I hope there is a technique that appeals to you or that you can use as a catalyst to finding your own inimitable style.

Clothes

Wardrobe is very important to a character since it's basically an extension of his or her personality. Consequently it's vital to keep up on trends, to be aware of what's current (unless you're in the social swim, and I think I drowned years ago). So if you're like me and haven't exactly been keeping up with the latest threads, it's a good idea to grab that trusty sketchbook and roam the streets or check out *People* magazine. Observe how people are currently doing their hair. Is it spiked, teased, shaved, curled or fluffed? Are they wearing jeans with ripped knees or well-pressed chinos? Short skirts or long? I recently took a morning stroll down Melrose Avenue here in Los Angeles and was pleased to observe (in about an hour) almost every contemporary style of dress—attractive and unattractive, bizarre and conservative—that exists in our modern culture. Here are a few of those sketches just to give you an idea of what the younger (and yes, even the older) generation is wearing (much of it, I might add, to my chagrin).

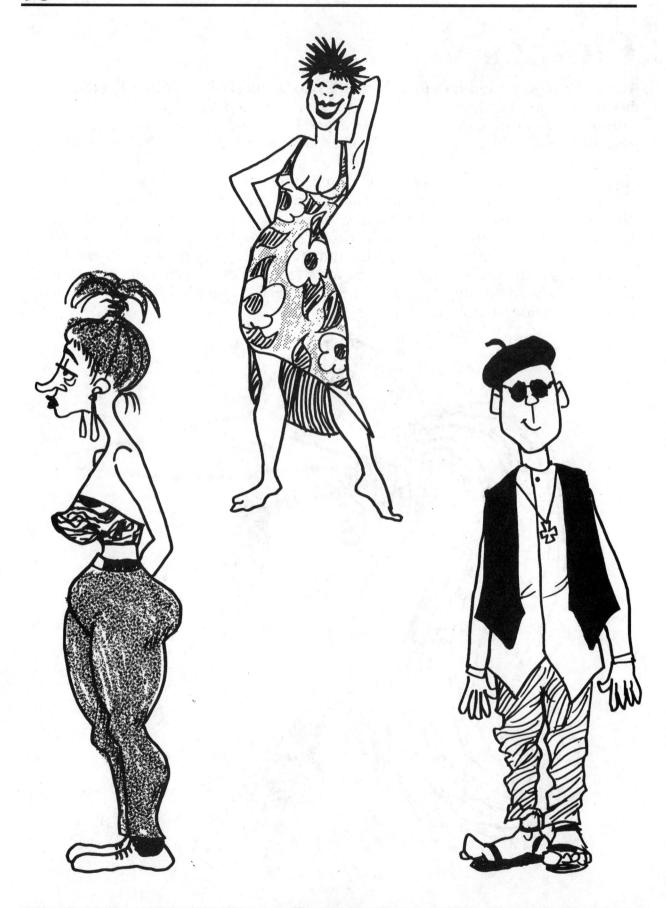

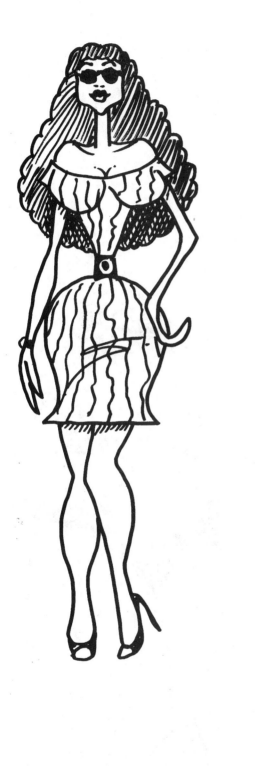

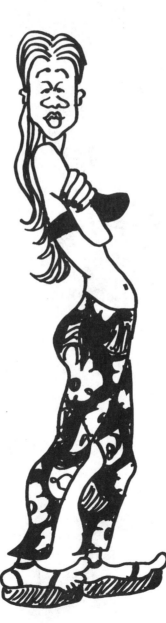

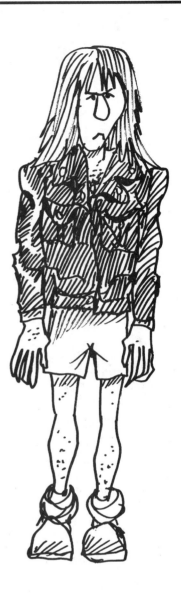

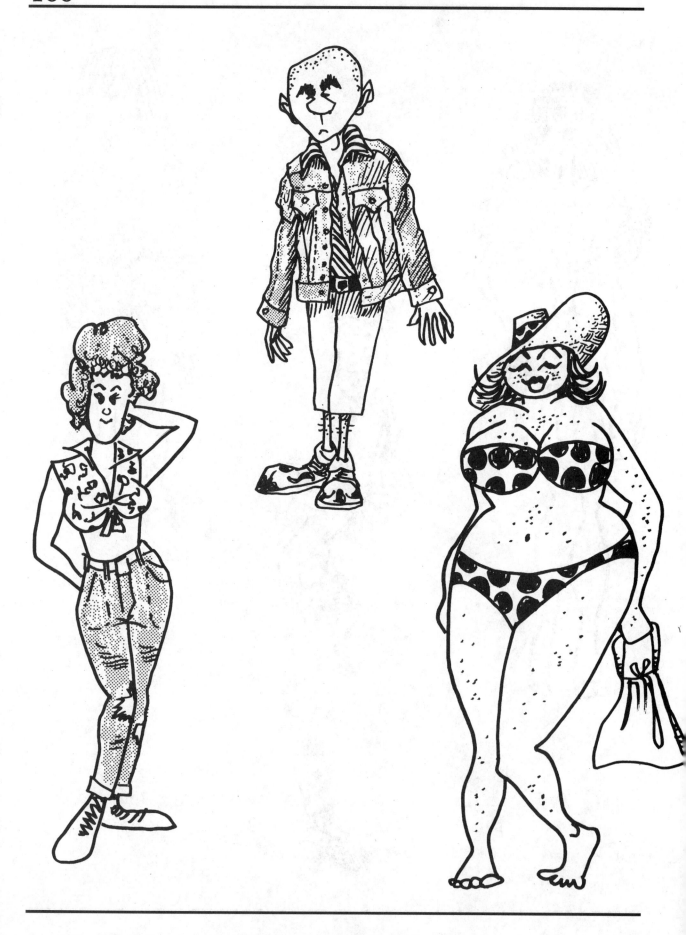

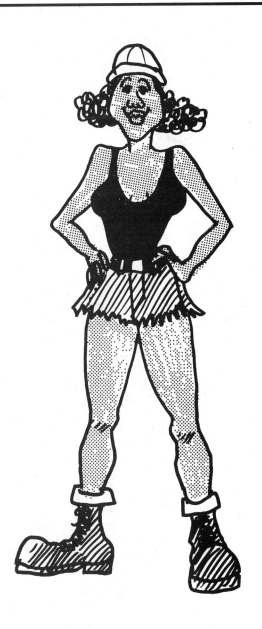

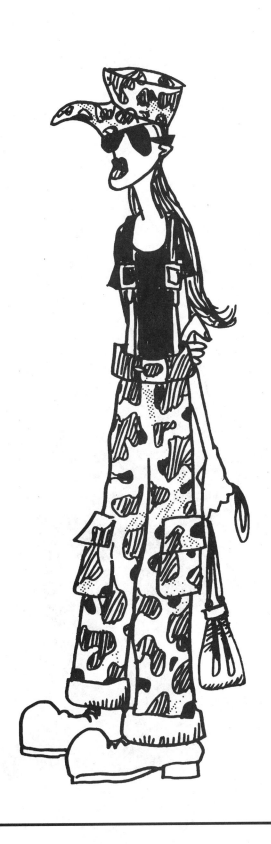

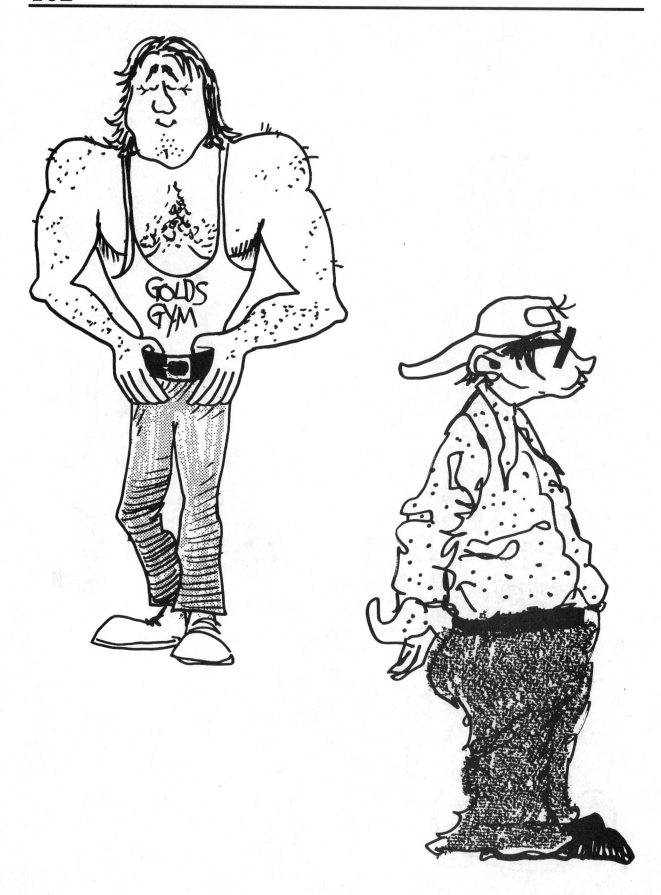

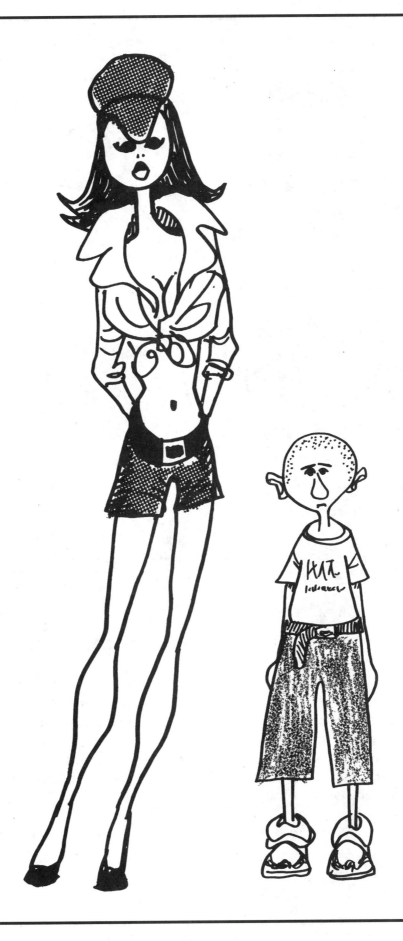

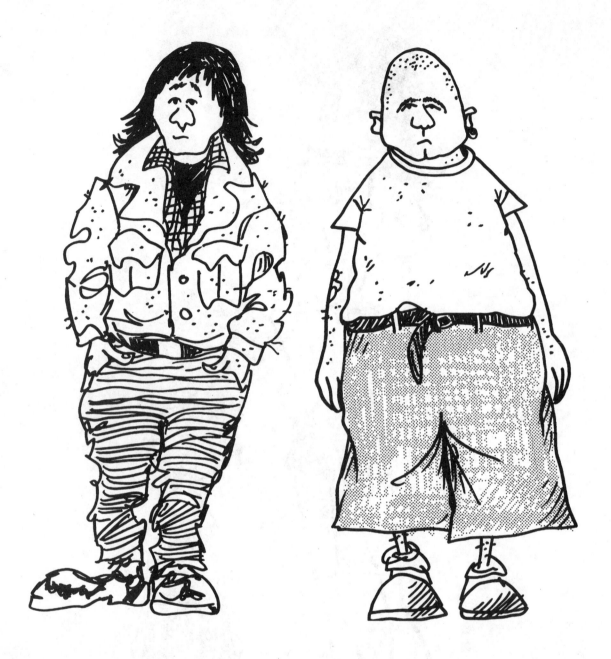

So keep your eyes open and stay on top of things. You don't want your work to appear dated merely because you neglected to do some simple and, I might add, fascinating research. Some artists even go so far as to keep a visual log on costumes from different eras because you never know when you might be asked to depict a guy or gal from the '30s, '50s, '60s or some other era. Your library is chock-full of handy reference photos—you might as well use it.

Okay, here we go . . . it's on to the weird stuff! Enter at your own risk!

To Bizarre or Not to Bizarre

Here's a question that's thrown at me all the time: "How far out and weird can I get with my drawings?" I don't know—how far is far? How weird is weird? This is strictly a personal choice. One man's distortion is another's turn-on (to paraphrase an old axiom). Of course it helps if the final result is still recognizable as a human being, but I believe we can go pretty far with distortion because today's more sophisticated viewer can stay right along with us.

You'll notice that in doing these bizarre characters I've relied a lot on extreme incongruity. The dictionary states that it's "not harmonious" and is "inconsistent with itself." It's one of those comedic devices that rarely fails.

For instance, the classic example of visual incongruity is a very large woman with a very tiny head. The small head serves to accentuate her size.

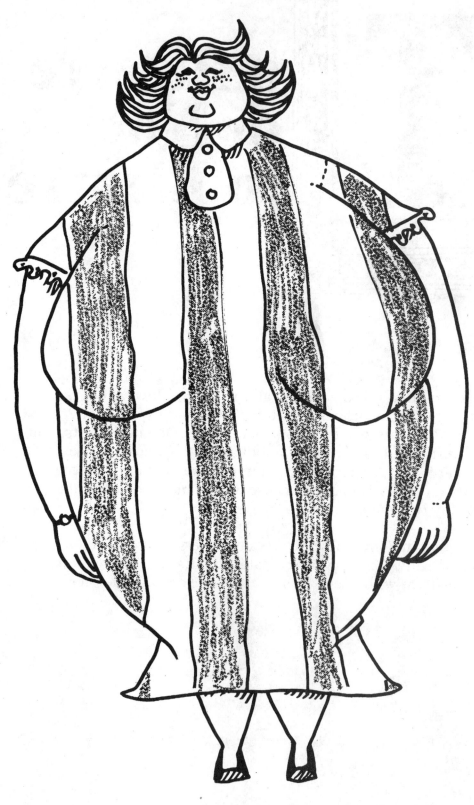

The incongruity of the tiny face and big hair gives this character a comical slant.

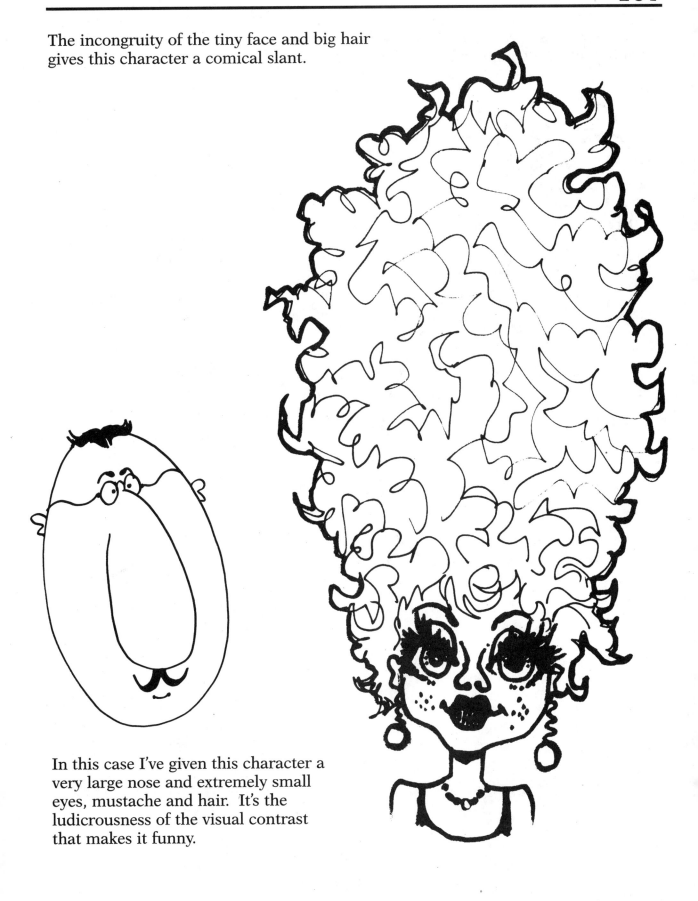

In this case I've given this character a very large nose and extremely small eyes, mustache and hair. It's the ludicrousness of the visual contrast that makes it funny.

With this guy it's his enormous chin, while the remainder of his features are squeezed into the top quarter of his face.

Here I've created a chinless guy with an extra-long nose, a tiny head and a little crewcut. All of the elements combine to produce a humorous effect. It's . . . how can I say it . . . visual disharmony—but *controlled* visual disharmony.

With this guy I've used a lollipop as inspiration. The round face, teeny little dotted eyes and thin neck are about as incongruous as you can get.

It's always great fun to play around with the folds and wrinkles of the face. For instance . . .

Wrinkles can sometimes rescue a drawing. What could be a fairly banal, pedestrian creation turns into an interesting one merely by "in-CREASING" it. (Okay, okay, I know—but you must allow me one bad pun per book.)

Here are a couple of sketches before and after the wrinkling process.

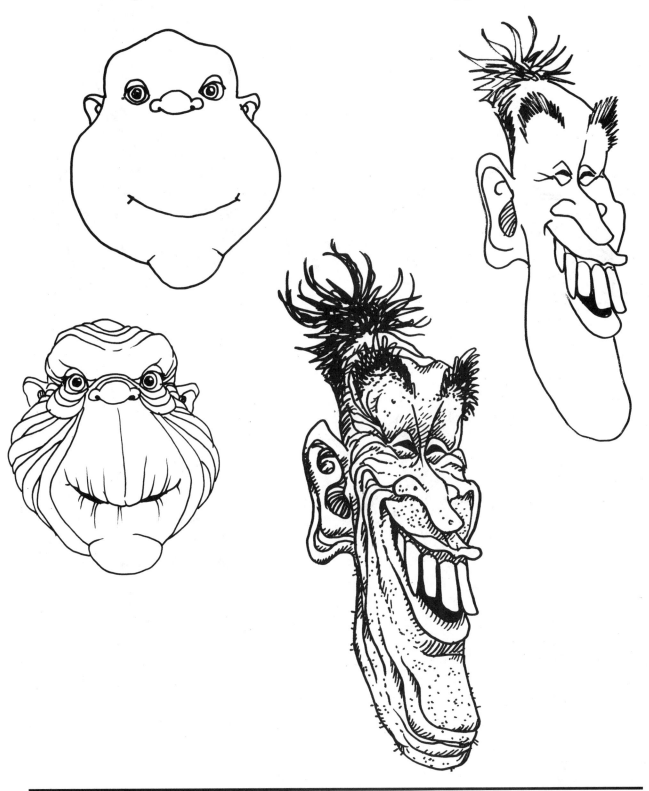

Okay, now it's your turn. Add wrinkles to these characters, but be sure not to add them arbitrarily; follow the folds and natural contours of the face to make them work.

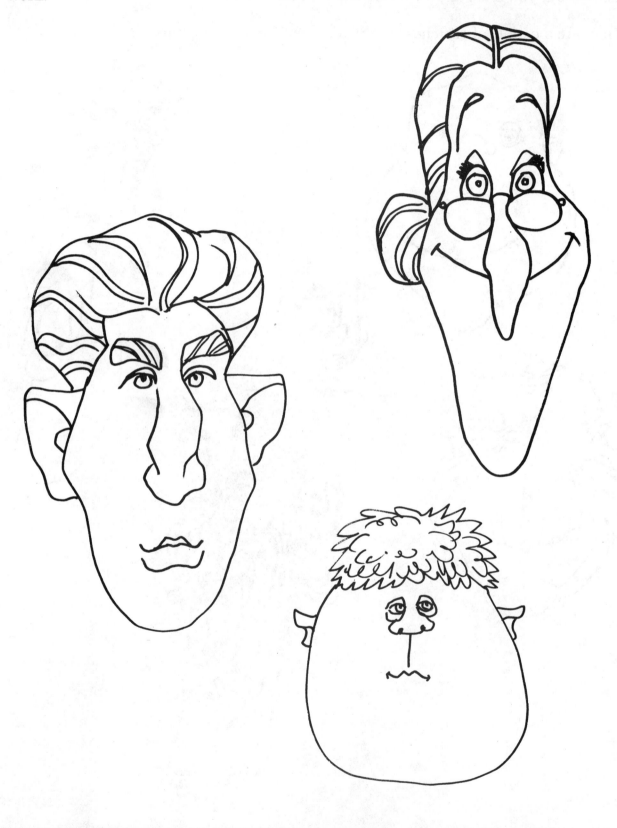

Personally my taste runs to the weird and warped. You tell me: are they too much? If not, dive in and see what you come up with. Top my weirdness if you dare; I've tossed my gauntlet at you.

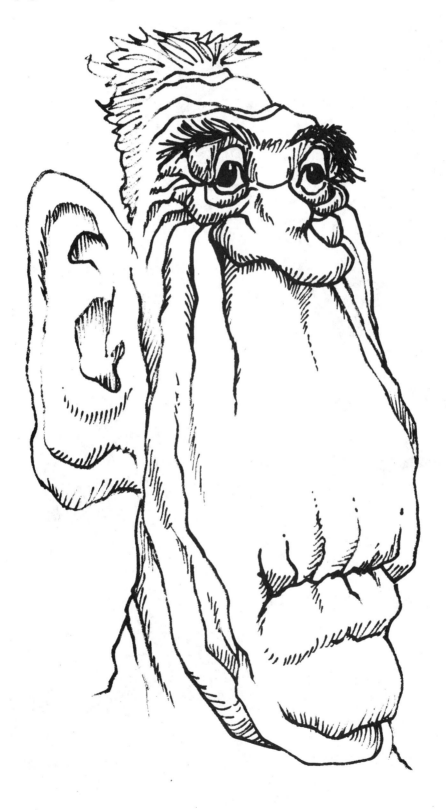

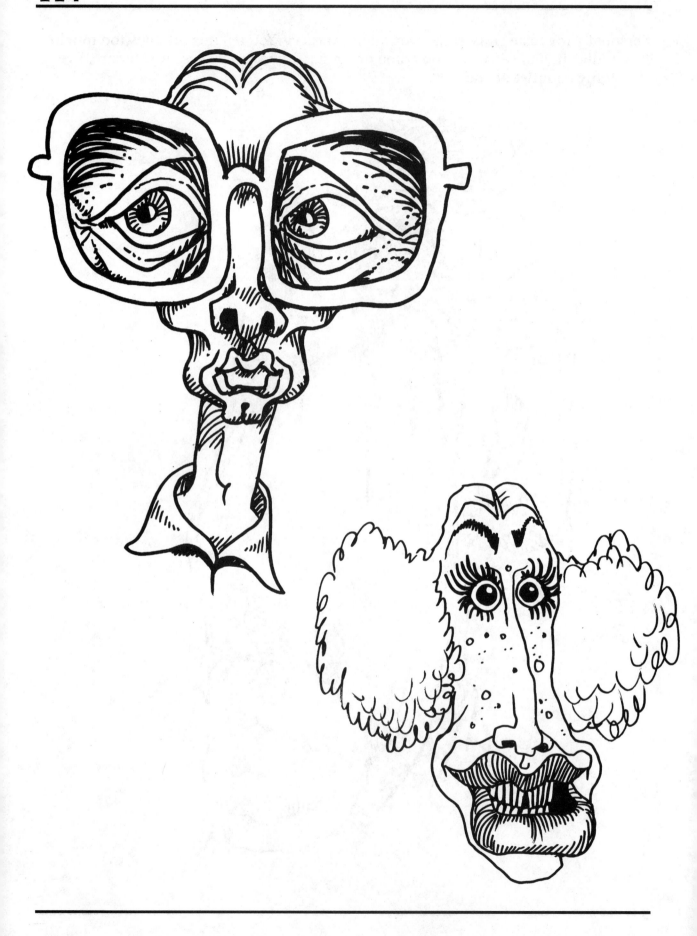

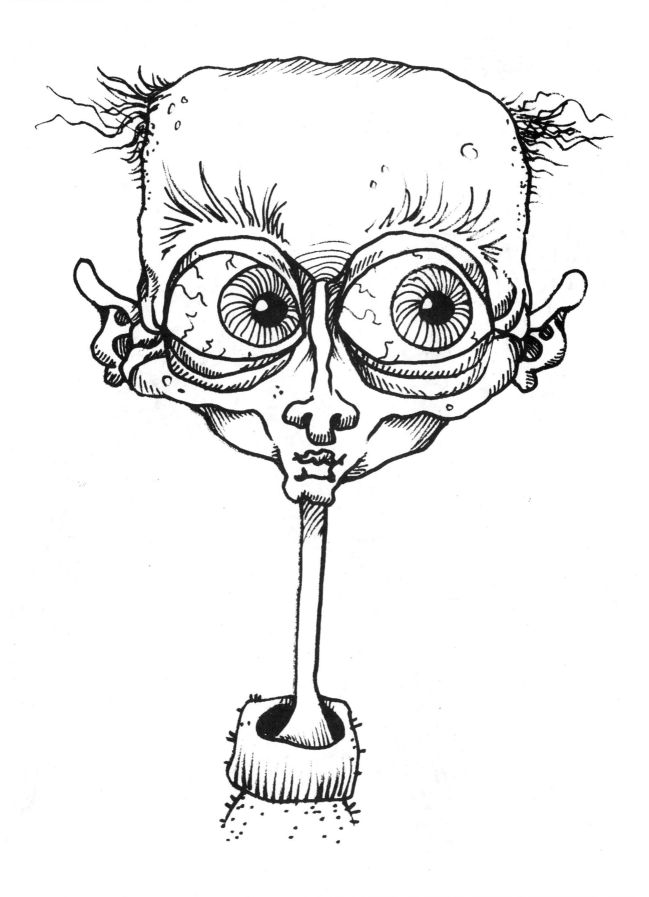

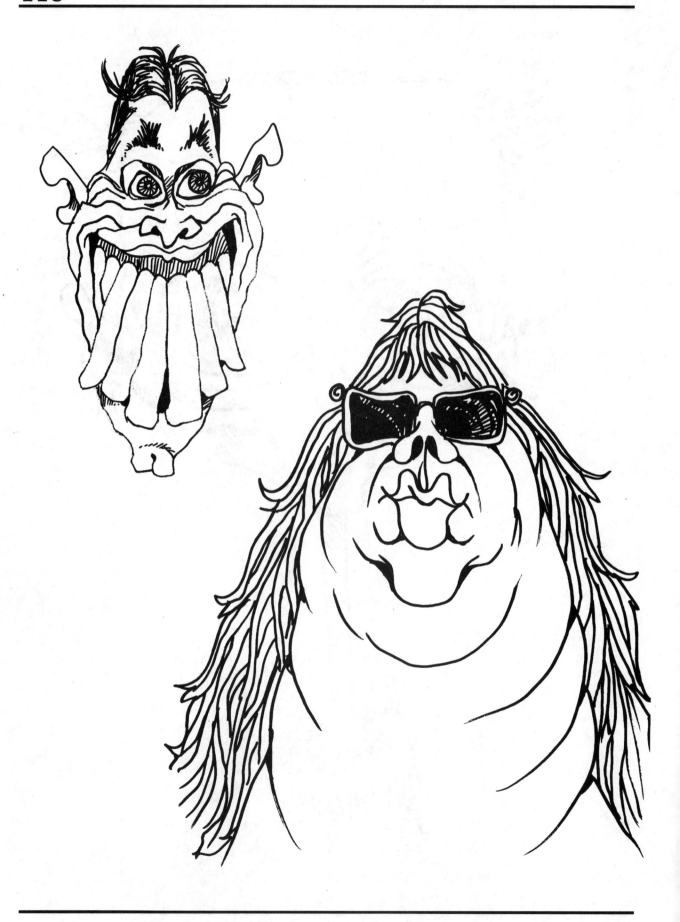

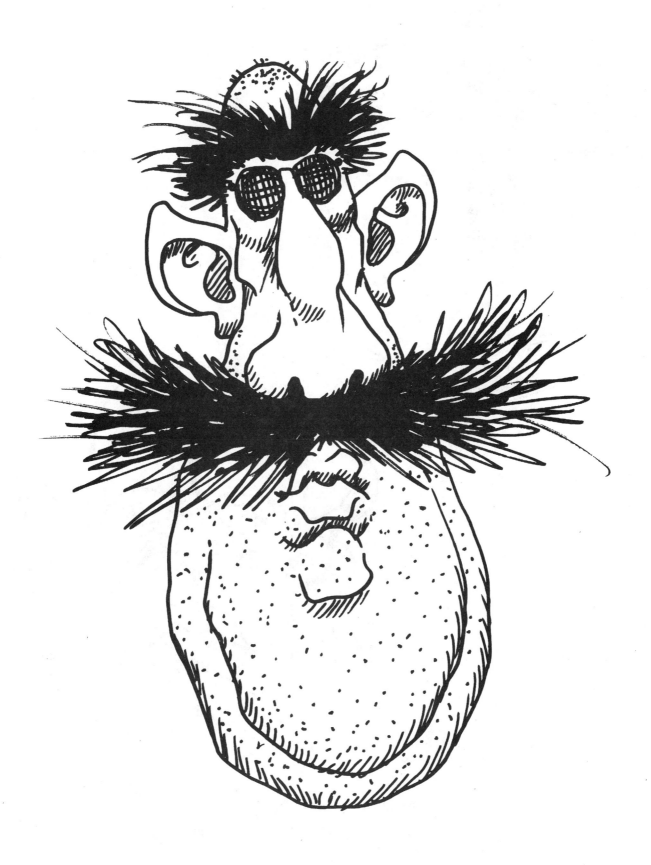

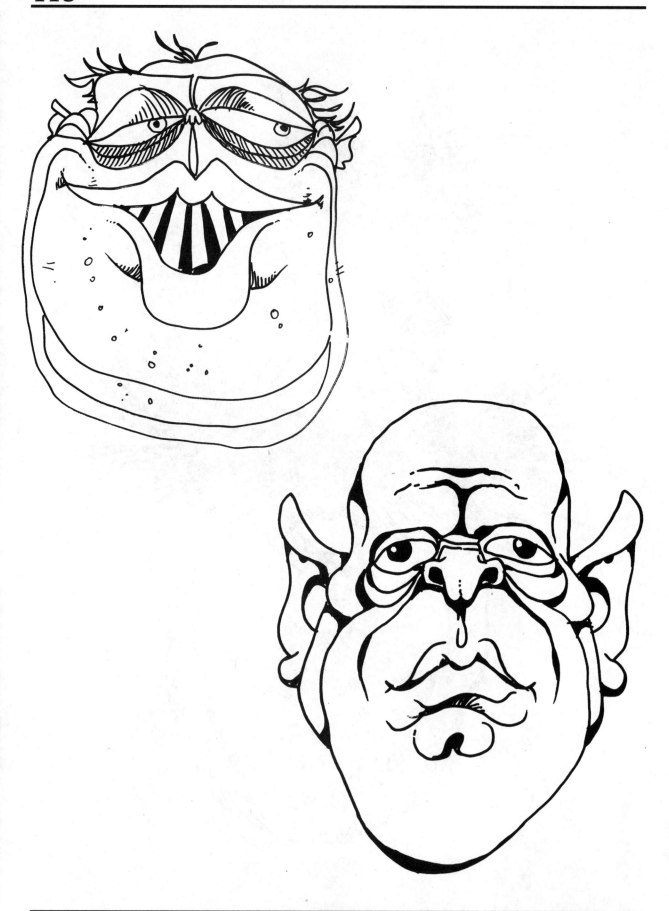

What Else Is There to Say?

So, as you can see, there's a lot more to cartooning than just "drawing silly pictures." It is an art form (though not universally recognized as such—yet), and one which contains many avenues through which to express yourself—and I know I've used this word too much in this book—and still have FUN (my computer screen keeps reminding me "You're using the word FUN too often," but I yell back at it, "No, I'm not, you pain-in-the-ROM"). Anyway, I encourage you to enjoy the creative process. And it doesn't matter whether you pursue it professionally or just for . . . there's that word again! What matters is that you're involved in a creative mode and you're being productive. Also, be assured that it doesn't matter how your art comes out right now. You're entitled to private experimentation. You don't like it? Toss it. Hide it. Don't show it until you're ready. Would a budding pianist play for anyone until they were sure of their skills? Nope. The same applies to artists. You'll know when you're on your way and when you're comfortable exposing your creations to family, friends and the world. But stay at it. Dogged persistence inevitably produces satisfying results.

I hope you've gotten a few ideas from this book, and I hope that I've succeeded in stimulating you and showing you some effective ways of breaking down barriers that were preventing you from growing as an artist. If I've done these things, I'm content. If you choose to pursue the muse of amusement to a professional level or just remain a

contented amateur, what matters is that you find joy in the creative process. Are you having any fun? Well, there you are, we can't ask for anything more than that.

So now I extend to you my best wishes for a successful run at cartooning as a lucrative career or a satisfying pastime. My only advice being . . . when it stops being fun, dump it! But, before you do, remember: I wrote this book in an effort to save you from that very sad choice. And if things start looking the same and you fall into that rut again, feel free to refer back to some of these exercises for a little instant inspiration to get those creative juices flowing again.

Keep cartooning alive, moving, and interesting by setting different goals and no parameters for yourself; you'll soon find that cartooning as an art will enrich your life.

About the Author

Dick Gautier was drawing cartoons for his high school paper in Los Angeles when he was sixteen, singing with a band when he was seventeen, and doing stand-up comedy when he was eighteen. After a stint in the Navy, he plied his comedy wares at the prestigious "hungry i" in San Francisco for a year before traveling to the East Coast, where he performed in all the major supper clubs; among his appearances was an extended run with Barbra Streisand at the Bonsoir in Greenwich Village. He was tagged at the Blue Angel by Gower Champion to play the title role in the smash Broadway musical *Bye Bye Birdie*, for which he won a Tony and Most Promising Actor nominations.

After two years he returned to Hollywood, and eventually starred in five TV series, including *Get Smart*, in which he created the memorable role of Hymie, the white-collar robot. In addition, he portrayed a dashing but daffy Robin Hood for Mel Brooks in *When Things Were Rotten*.

Add to this list guest-starring roles in more than 300 TV shows, such as *Matlock*, *Columbo*, and *Murder, She Wrote*, and appearances on *The Tonight Show*, and roles in a slew of feature films with Jane Fonda, Dick Van Dyke, George Segal, Debbie Reynolds, Ann Jillian, James Stewart, etc., etc. He has won awards for his direction of stage productions of *Mass Appeal* and *Cactus Flower* (with Nanette Fabray), and has written and produced motion pictures.

Gautier is the author/illustrator of *The Art of Caricature, The Creative Cartoonist, The Career Cartoonist, Drawing and Cartooning 1,001 Faces, Drawing and Cartooning 1,001 Figures in Action,* and *Drawing and Cartooning 1,001 Caricatures* for Perigee Books, a children's book titled *A Child's Garden of Weirdness,* and two coffee-table books with partner Jim McMullan titled *Actors as Artists* and *Musicians as Artists.* He's done just about everything but animal orthodontics, and don't count him out on that yet. No wonder he refers to himself as a "Renaissance dilettante."

Of all his accomplishments, Gautier is proudest of the fact that he's never hosted a talk show, or gone public with tales of drug rehabilitation and a dysfunctional family life.